Gabriele Münter

The Search for Expression 1906–1917

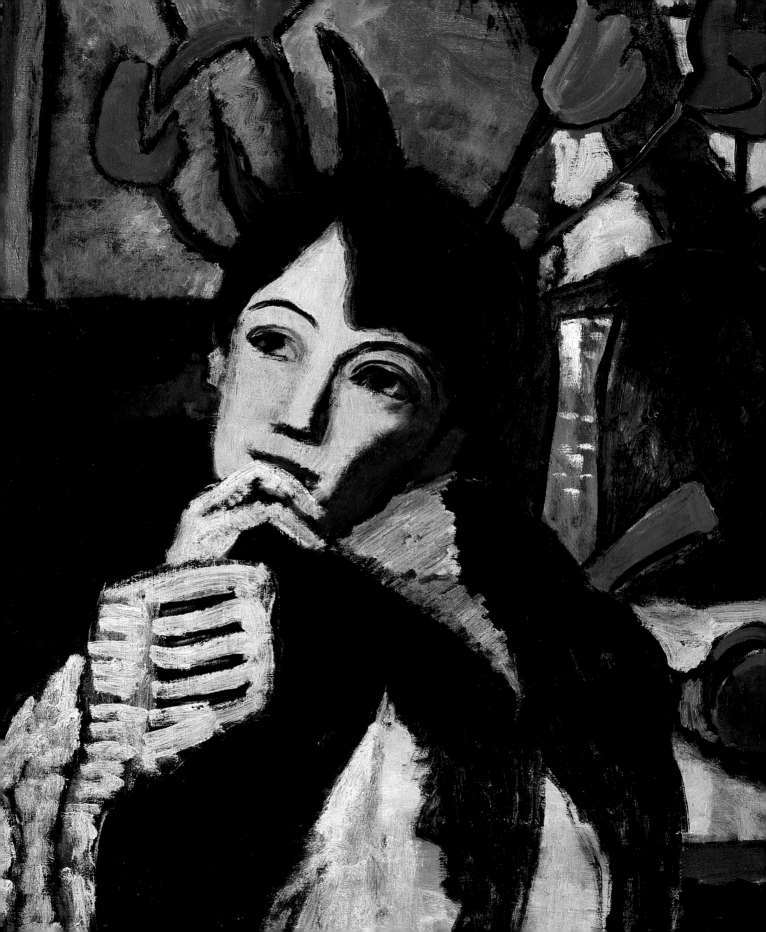

With essays by
Annegret Hoberg and Shulamith Behr
Catalogue by Barnaby Wright

Gabriele Münter
The Search for Expression 1906–1917

COURTAULD INSTITUTE OF ART GALLERY
IN ASSOCIATION WITH
PAUL HOLBERTON PUBLISHING, LONDON

First published 2005 to accompany the exhibition
Gabriele Münter: The Search for Expression 1906 – 1917
at the Courtauld Institute of Art Gallery,
Somerset House, London, 23 June – 11 September 2005

ISBN 1 903470 29 3

British Library Cataloguing in Publication Data
A catalogue record for this book is available
from the British Library

Produced by Paul Holberton publishing,
37 Snowsfields, London SE1 3SU
www.paul-holberton.net

Designed by Philip Lewis

Origination and printing by
Graphic Studio, Bussolengo, Verona, Italy

Cover image: *Listening (Portrait of Jawlensky)* (cat. 10) (detail)
Back cover: *Jawlensky and Werefkin* (cat. 9)
Frontispiece: *Reflection* (cat. 21) (detail)
Page 8: *Street in Murnau* (cat. 6) (detail)
Page 10: *Man at a Table (Kandinsky)* (cat. 16) (detail)

Contents

Foreword

As a university museum the Courtauld Institute Gallery occupies a particular place in the wide spectrum of art museums in Britain. This role is articulated in its close support of the academic activities of the Courtauld Institute of Art and, most visibly, in the focused nature of its exhibitions, which seek to contribute to the understanding and enjoyment of art by placing advanced object-based research in the public domain. The Gallery's exhibitions derive from a conviction that its distinctive contribution lies in providing its visitors with opportunities for focused in-depth inquiry, often concerning artists or works not otherwise readily available in the national collections.

The present exhibition of twenty-one paintings produced by Gabriele Münter between 1906 and 1917 is an expression of that approach in that it offers a concentrated account of a figure who remains little known in Britain. In particular it examines the period of Münter's most intensive and searching creativity, from her emergence as an original artistic personality alongside Kandinsky to her association with the *Blaue Reiter* group and the beginning of her self-imposed exile in Scandinavia. It is a period characterised above all by a profoundly experienced and liberating sense of possibility, discovery and renewal.

A series of important exhibitions have done much in the last twenty years to redress the historically held British view of early twentieth-century German art as of peripheral interest and marginal to the development of modernism. Until recently the Courtauld's ability to contribute to this development rested almost entirely in the excellence of its teaching and research. In 2002, however, the Gallery received the loan of over one hundred

modernist paintings and sculptures, including a distinguished group of German Expressionist works. These loans, for which we are indebted above all to the Fridart Foundation, provided the initial impetus for the present exhibition. The exhibition itself would not have been possible without the exceptional generosity of the Städtische Galerie im Lenbachhaus in Munich, which has contributed no less than eighteen paintings.

The Lenbachhaus is world-renowned for its *Blaue Reiter* collection, much of which was presented by Gabriele Münter, and that it has agreed to lend so freely of paintings regarded as a central to its displays expresses a deep commitment to shared cultural and intellectual values. We are particular grateful in this respect to Helmut Friedel, Director of the Lenbachhaus, who has supported the project from its inception, to Annegret Hoberg, Senior Curator of the *Blaue Reiter* collection, who has contributed a lucid introductory essay to this catalogue, and to Ilse Holzinger of the Gabriele Münter- und Johannes Eichner-Stiftung. At the Courtauld particular thanks are due to Shulamith Behr, who has been an exemplary and expert collaborator, to Barnaby Wright for his able and unassuming stewardship of the project, and to our colleagues in the Registrar's and Development offices for their steady efficiency. Above all we extend our warm thanks to the group of institutional and private supporters, many of them friends of long standing, who shared our belief in the importance of this exhibition, the first of Münter's work in a British museum. Finally we wish to thank the German Embassy in London for its assistance and encouragement. The Courtauld Institute of Art is particularly honoured that His Excellency Thomas Mattusek is the patron of the exhibition.

ERNST VEGELIN VAN CLAERBERGEN
Courtauld Institute of Art Gallery

Foreword

It was with great pleasure that I accepted the invitation to become Patron of the Gabriele Münter Supporters' Circle, a group whose generosity has made this important exhibition possible at the Courtauld Institute of Art Gallery. As the first ever museum exhibition of Münter's work in Britain it brings her paintings to a new audience outside Germany and highlights the crucial role Münter played in the history of German Expressionism. I hope that these stunning paintings will be a revelation to visitors and inspire further interest in her significant contribution to the international development of modern European art.

Gabriele Münter: The Search for Expression is the result of an important collaboration between the Courtauld Institute of Art and the Städtische Galerie im Lenbachhaus, Munich, which has lent many of the paintings to this exhibition. Both these world-famous institutions share a passionate commitment to promoting public understanding and enjoyment of art and culture. The German Embassy in London is pleased to have been able to contribute to this special collaboration through support of this exhibition.

THOMAS MATUSSEK
Ambassador of the Federal Republic of Germany

GABRIELE MÜNTER SUPPORTERS' CIRCLE

The Courtauld Institute of Art Gallery relies substantially on its friends and supporters to mount its programme of special exhibitions. We would like to thank His Excellency the German Ambassador for his personal support of this project, as well as the following contributors to the Gabriele Münter Supporters' Circle for their generous gifts which have made this exhibition possible.

His Excellency Mr Thomas Matussek,
AMBASSADOR OF THE FEDERAL REPUBLIC OF GERMANY (Patron)
Apax Partners
Mrs Elke von Brentano
Mrs Karin Emery and family
Mr and Mrs Nicholas Ferguson
Mallinckrodt Foundation
Dr Wilhelm Winterstein, Munich
Anonymous donor

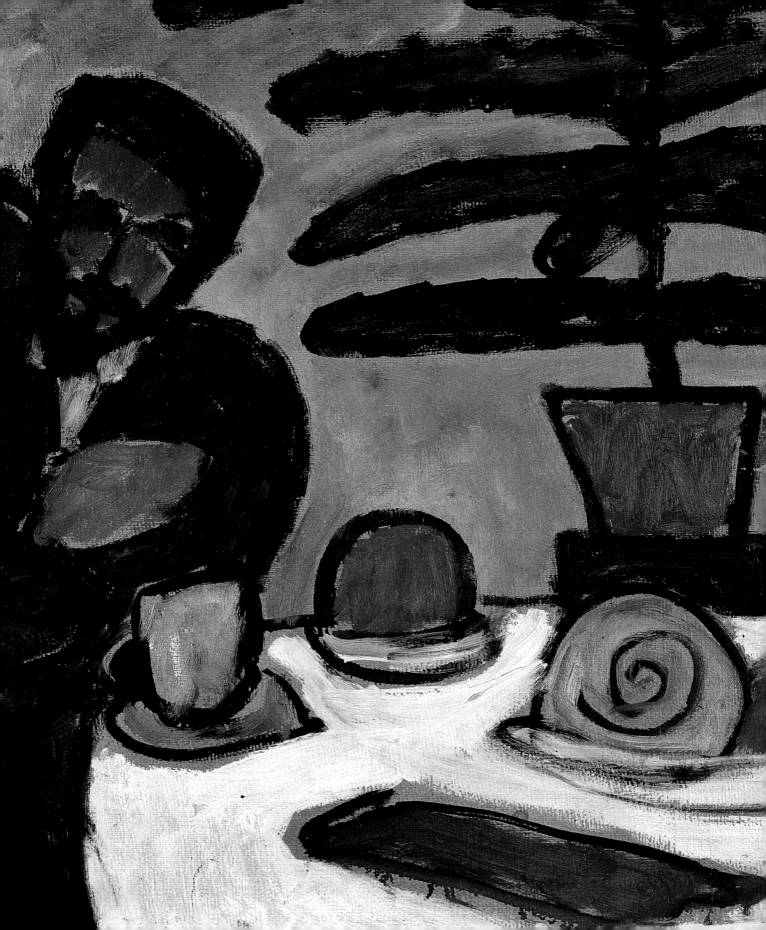

Acknowledgements

This exhibition would not have been possible without the generous loans from the Städtische Galerie im Lenbachhaus, Munich, and we extend our warm thanks to its Director, Helmut Friedel, and Senior Curator, Annegret Hoberg. At the German Embassy in London, Anne-Marie Schleich provided invaluable advice and assistance. Ilse Hölzinger, Executive Director of the Gabriele Münter- und Johannes Eichner-Stiftung, greatly aided the research needed for this exhibition by facilitating access to its archive. Anna Müller-Härlin, of the Sprengel Museum, provided assistance with research material based in Hanover.

At the Courtauld Institute of Art, Uschi Payne, Mary Ellen Cetra and Sarah Wilson each played an important role in bringing the exhibition and publication to fruition. We should also like to acknowledge the support of the Courtauld Institute of Art's Research Committee.

Chronology

1877 Gabriele Münter born on 19 February in Berlin, the youngest of five children. Her parents, Carl Friedrich Münter and Wilhelmine Scheuber, had met in the United States of America, where they had emigrated and were married in 1857. They returned to Germany in December 1864 and settled in Berlin. Carl Münter, who had studied dentistry in Cincinnati, Ohio, established himself as an 'American dentist'.

1878 The family moves into a newly built house in Herford.

1884 Following a brief move to Bad Oeynhausen, the family settle in Koblenz.

1886 Two months after Münter's ninth birthday her father dies, aged fifty-nine.

1897 Moves to Düsseldorf to start private drawing and painting classes with Ernst Bosch. Joins the Ladies' School of the Düsseldorf Academy under Professor Willy Spatz. In November, her mother dies, aged sixty-one. A trust fund is set up for the Münter children.

1898– Leaves for the United States with her
1900 sister and travels extensively around the country visiting relatives. Receives a Kodak camera for her twenty-second birthday. Moves to Bonn to study with the sculptor Hermann Küppers.

1901 Moves to the bohemian district of Schwabing in Munich and enrols in the Ladies' Academy of the Association of Women Artists to study drawing from the partially clothed nude, portrait drawing and landscape drawing under Maximilian Dasio.

1902 Enrols in Wilhelm Hüsgen's sculpture classes at the Phalanx School, which is chaired by Wassily Kandinsky. Attends Kandinsky's classes, drawing and painting from the nude and making portraits, finding them inspirational. In the summer, joins his *plein-air* landscape painting lessons in Kochel and Walchensee. As they spend increasing amounts of time together, their relationship becomes intimate.

1903 Stays with Kandinsky in Kallmünz, where they get engaged secretly and plan to marry after he has obtained a divorce. Continues to draw and paint under his tutelage.

1904–05 Travels extensively with Kandinsky painting and sketching in Germany, the Netherlands, North Africa, Belgium, France and Italy, where they rent a house in Rapallo.

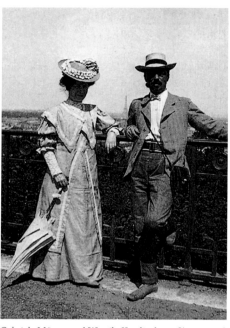

Gabriele Münter and Wassily Kandinsky in Sèvres, 1906
Gabriele Münter- und Johannes Eichner-Stiftung, Munich

Gabriele Münter painting in Kochel, July 1902
Gabriele Münter- und Johannes Eichner-Stiftung, Munich

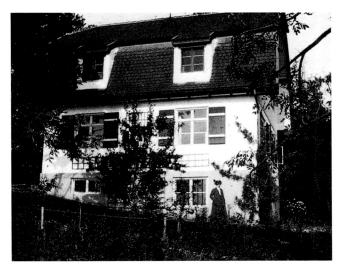

Gabriele Münter outside 'the Russians' House', Murnau, 1910
Gabriele Münter- und Johannes Eichner-Stiftung, Munich

1906 Moves with Kandinsky to Sèvres and rents an apartment near to the Park St-Cloud. They produce numerous oil studies of the park and town. Münter makes a series of linocut and woodcut prints, including portraits and views of the surrounding area. In November, takes a room at no. 58 rue Madame in Paris and participates in Théophile Steinlen's figure-drawing lessons at the *Académie Grande Chaumière*.

1907 Continues working in Paris (until March) and Sèvres. Exhibits six paintings at the Paris *Salon des Indépendants*. Leaves Sèvres for Cologne in June to arrange a solo exhibition. Exhibits a selection of prints at the Paris *Salon d'Automne* in October.

1908 Exhibits eighty paintings at her first solo show, which opens at the Kunstsalon Lenoble in Cologne. Exhibits at the *Salon d'Automne* and the *Salon des Indépendants*. Moves to Munich with Kandinsky and they embark on tours of the surrounding Bavarian countryside, where they become enamoured of the market town of Murnau. Returning to Munich they establish contact with the Russian artists Marianne Werefkin and Alexej Jawlensky. All four return to

Murnau, taking rooms for the summer at the Griesbräu inn. Münter sketches and paints intensively, making what she later described as 'a great leap' in her artistic practice. Returns to Munich in September.

1909 Founding member of the avant-garde *Neue Künstlervereinigung München* (NKVM; New Artists' Association Munich) together with Kandinsky,

Wassily Kandinsky in the garden of 'the Russians' House', Murnau, 1909
Gabriele Münter- und Johannes Eichner-Stiftung, Munich

Gabriele Münter in the garden of 'the Russians' House', Murnau, 1909
Gabriele Münter- und Johannes Eichner-Stiftung, Munich

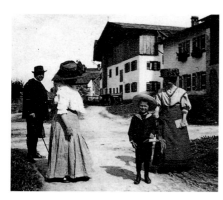

Alexej Jawlensky, Marianne Werefkin, Andreas Jawlensky and Gabriele Münter in Murnau, summer 1908 or spring 1909
Gabriele Münter- und Johannes Eichner-Stiftung, Munich

Werefkin and Jawlensky, among others. Travels to the alpine town of Kochel with Kandinsky and produces a number of paintings of the cemetery and landscape. In Murnau for spring and summer with Jawlensky and Werefkin, Kandinsky encourages her to buy a recently built house on the outskirts of the town which becomes known as 'the Russians' House'. Begins to collect local folk art, particularly of Bavarian and Bohemian glass painted in the technique known as *Hinterglasmalerei* (painting behind glass), which she starts to learn. Exhibits work at the NKVM exhibition at the Galerie Thannhauser in Munich, also travelling to other German cities. Also exhibits at the *Salon d'Automne*.

1910 Spends time in Murnau working on the house and its gardens. Returns frequently to Munich and exhibits a number of large paintings in the second NKVM exhibition in September, which includes work by Georges Braque, André

Derain and Pablo Picasso, among others. Exhibits at the *Salon d'Automne*. In December, exhibits work at the *Salon Izdebsky* in Odessa and the *Karo Bube* (Jack of Diamonds) exhibition in Moscow.

1911 In Munich meets Franz Marc and his wife Maria and together with Kandinsky they make plans to publish an almanac, *Der Blaue Reiter* (The Blue Rider). Exhibits at the *Salon des Indépendants*. In August, stays with her brother in Bonn and meets August Macke, paying several visits to his studio. In December, resigns from the NKVM with Kandinsky, Marc and Alfred Kubin and they establish

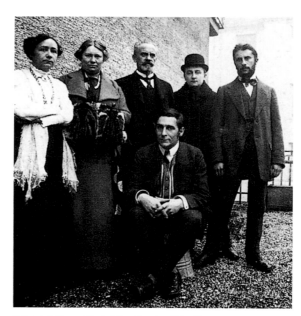

Gabriele Münter, Maria Marc, Bernhard Koehler, Thomas von Hartmann, Heinrich Campendonk and Franz Marc (seated) on the terrace of Ainmillerstrasse 36, Munich, 1911
Photograph by Wassily Kandinsky
Gabriele Münter- und Johannes Eichner-Stiftung, Munich

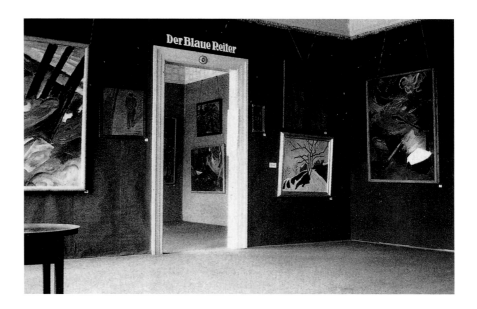

The *Blaue Reiter* exhibition, Munich,
1911–12
Photograph by Gabriele Münter
Gabriele Münter- und Johannes
Eichner-Stiftung, Munich

their new group, *Der Blaue Reiter*, which holds its first exhibition at the Galerie Thannhauser. Kandinsky obtains a divorce from his first wife but marriage to Münter remains unproposed.

1912 The *Blaue Reiter* exhibition travels to Cologne and Berlin, where it is shown at Herwarth Walden's new *Sturm* Gallery in March. Exhibits in the second *Blaue Reiter* exhibition in Munich at Kunst-handlung Hans Goltz, which is devoted to works on paper. Her paintings are reproduced in the *Blaue Reiter* almanac, published in May. Exhibits at the *Salon des Indépendants*.

1913 In March, a retrospective exhibition of eighty-four of Münter's paintings from 1904 to 1913 opens at Walden's *Sturm* Gallery and travels, in a reduced form, around Germany. Spends time with Kandinsky in Murnau and Munich until July, when he leaves for two months in Moscow and she travels around Germany visiting relatives.

1914 Exhibits at the 'Expressionist Painting' exhibition in Dresden and Breslau. Spends the summer with Kandinsky in Murnau. In August, following the outbreak of war, they quickly collect

their belongings from Munich and flee to Switzerland. Kandinsky returns to Russia and Münter stays in Zurich.

1915 Arranges a small exhibition of her paintings in Zurich before returning to Munich. Writes to Kandinsky urging him to meet her in Stockholm but he refuses. Nevertheless, she travels to Stockholm in July and establishes contact with a number of artists, including Carl Palme, who was a fellow student at the *Phalanx* school. Kandinsky finally agrees to join her and he arrives in late December.

1916 Helps to organise an exhibition of Kandinsky's work at the Gummeson Gallery in Stockholm, which also holds a show of Münter's work. Edits Kandinsky's essay 'On the Artist', which accompanies his exhibition, before he returns to Russia in March. Travels to Lapland and Norway with Gertrude Holz. Returning to Stockholm, Münter spends much of her time in the company of female friends and produces a number of portraits. Three of her earlier works are included in the summer exhibition at *Der Sturm*, 'Expressionists, Futurists, Cubists'. Despite her sending letters imploring Kandinsky to return to Sweden, he remains in Russia and in

September he begins a relationship with Nina Andrejewska. Münter and Kandinsky were never to meet again.

1917 Exhibits thirty-one of her Scandinavian paintings at the Association of Swedish Women Artists and the Association of Women Artists of Austria's joint exhibition in Stockholm. Embarks on a series of paintings of women in interiors, mainly using Gertrude Holz as her model. From the end of May, Kandinsky stops replying to her letters, having married Nina Andrejewska in February without Münter's knowledge. Exhibits ninety-five works at the Nya Gallery in Stockholm. In November, leaves for Copenhagen and makes plans for a large exhibition there at *Den Frie Udstilling* (Independent Exhibition).

1918 *Den Frie Udstilling* show opens in March and is her largest exhibition to date. It includes one hundred paintings together with prints and glass paintings.

1919 Facing mounting financial difficulties, advertises for students but only one pupil joins her landscape painting course in the summer. Organises another large exhibition in Copenhagen and is included in the winter exhibition at *Der Sturm*.

1920 Leaves Copenhagen and spends the
 summer in Murnau.

1921–28 Although her artistic production
 dwindles, continues to exhibit in
 Germany whilst moving between
 Munich, Murnau, Cologne and Berlin.
 Tries repeatedly to contact Kandinsky
 but to no avail. His agent contacts her
 to try to retrieve some of his works
 but Münter insists Kandinsky write
 personally. Eventually he concedes and
 an acrimonious correspondence ensues.
 It is not until 1926 that agreement is
 reached over their property disputes.
 Begins work in 1925 on a text entitled
 'Beichte und Anklage' (Confession and
 Accusation), which she completes in
 1928, around the time she begins a
 relationship with the art historian
 Johannes Eichner.

1929–30 Lives with Eichner in Paris and the
 South of France.

1931–33 Moves to Murnau with Eichner, who
 begins writing about her work and
 organises a retrospective exhibition
 that travels around Germany over
 the next two years.

1934–36 The exhibition arouses hostility from
 National Socialist supporters and
 Eichner encourages her to produce more
 commercially viable work. Submits work
 to one of the Nazi projects for the 1936
 Berlin Olympics and has two paintings
 shown in the travelling exhibition 'Adolf
 Hitler's Streets in Art'.

1937 To celebrate her sixtieth birthday the
 Heimatmuseum in Herford holds a solo
 exhibition of her work. Produces new

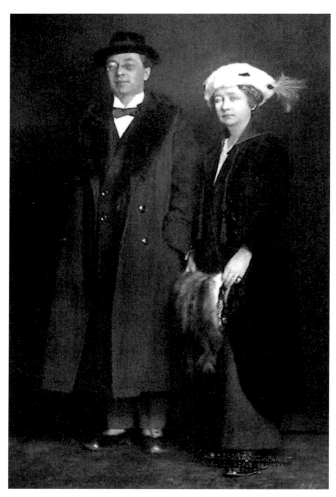

Wassily Kandinsky and Gabriele Münter in
Stockholm, winter 1916
Gabriele Münter- und Johannes Eichner-Stiftung, Munich

work for an exhibition in Munich
that is attacked in the Nazi press and
condemned by Nazi officials. Eichner
submits some of her paintings to the
Nazis' 'Great German Art Exhibition' in
Munich but they are rejected. In August
the couple visit this exhibition of officially
sanctioned art as well as the *Entartete
Kunst* (Degenerate Art) exhibition of
officially condemned art, which includes
work by Kandinsky, Marc and Jawlensky.

1938–45 Lives with Eichner in Murnau, producing
only a small amount of work to sell or
barter with little contact beyond the
town. Hides her collection of *Blaue Reiter*
works in the basement of the house to
prevent it being seized by the Nazis.

1946–57 Visited frequently in Murnau by critics
and art historians as part of the revival
of interest in German modernism in
general and the *Blaue Reiter* in particular.
Helps organise a large exhibition
devoted to the *Blaue Reiter* which opens
in Munich in 1949. Eichner organises a
retrospective of her work, which tours
Germany for four years. In 1957 she
donates a large part of her *Blaue Reiter*
collection to Munich's Städtische Galerie
im Lenbachhaus (Municipal Gallery at
the Lenbachhaus).

1958 Eichner dies suddenly and Münter lives
alone in Murnau. She continues to be
visited by art historians and collectors.

1962 Gabriele Münter dies on 19 May in her
Murnau house, aged eighty-five.

Gabriele Münter in 'the Russians' House', Murnau, 1957
Gabriele Münter- und Johannes Eichner-Stiftung, Munich

A more extended biographical chronology can be found in
Reinhold Heller, *Gabriele Münter: The Years of Expressionism,
1903–1920*, exh. cat., Milwaukee and elsewhere, Prestel,
Munich and New York, 1998, pp. 9–30.

Principal Exhibitions

SOLO

Kunstsalon Lenoble, Cologne: 1908

Kunstbuchhandlung Friedrich Cohen: 1908

Galerie Der Sturm, Berlin: 1913 (touring retrospective, including
 Der Neue Kunstsalon Max Dietzel, Munich), 1915, 1917
 (with Gösta Adrian-Nilsson and Paul Klee)

Carl Gummesons Konsthandel, Stockholm: 1916

Liljevalchs Konsthall, Stockholm: 1917

Nya Konstgalleriet Ciacelli, Stockholm: 1917 (with Georg Pauli)

Den Frie Udstilling, Copenhagen: 1918

Ny Kunstsal, Copenhagen: 1919

Moderne Galerie Heinrich Thannhauser, Munich: 1920

Bremen: 1933–35 (touring retrospective)

Kunstverein Braunschweig: 1949-53 (touring, including Central
 Collecting Point, Munich: 1952)

Kestner-Gesellschaft, Hanover: 1951 (with Paula Modersohn-Becker)

Moderne Galerie Otto Stangl Munich: 1954 (touring, with Wassily
 Kandinsky and Franz Marc)

Städtische Galerie im Lenbachhaus, Munich: 1957 (with Wassily
 Kandinsky), 1962 (retrospective)

Dalzell Hatfield Galleries, Los Angeles: 1960 (with Wassily
 Kandinsky), 1963 (retrospective)

Marlborough Fine Art Ltd, London: 1960

Leonard Hutton Galleries, New York: 1961

View of a wall of Gabriele Münter's exhibition at Liljevalchs Kontshall,
Stockholm, 1917
Gabriele Münter- und Johannes Eichner-Stiftung, Munich

GROUP

Salon des Indépendants, Paris: 1907–08, 1911–12

Salon d'Automne, Paris: 1907–10

Neue Künstlervereinigung München, Galerie Thannhauser, Munich: 1909, 1910 (touring)

Izdebsky Salon, Odessa: 1910

Bubnovy Valet (Jack of Diamonds), Moscow: 1910, 1912

Neue Sezession, Galerie Macht, Berlin: 1911

Galerie Thannhauser, Munich: 1911–12 ('Der Blaue Reiter')

Kunsthandlung Hans Goltz, Munich, and Galerie Der Sturm, Berlin: 1912 ('Der Blaue Reiter')

Paul Cassirer, Berlin: 1913

Galerie Der Sturm, Berlin: 1913 ('Erster Deutscher Herbstsalon')

Galerie Ernst Arnold, Dresden: 1913–14 ('Die neue Malerei')

Galerie Nierendorf, Berlin: 1927 ('Die schaffende Frau in der bildenden Kunst')

Galerie Rudolf Wiltschek, Berlin: 1930

Haus der Kunst, Munich: 1949 ('Der Blaue Reiter und die Kunst des 20. Jahrhundert 1908–1914')

Kunsthalle, Basle: 1950 ('Der Blaue Reiter 1908–1914. Wegbereiter und Zeitgenossen')

Staatliche Kunsthalle Baden-Baden: 1960 (with Alfred Lörcher and Emy Roeder)

Tate Gallery, London: 1960 ('The Blue Rider Group')

Kunstmuseum Winterthur: 1961 ('Der Blaue Reiter und sein Kreis')

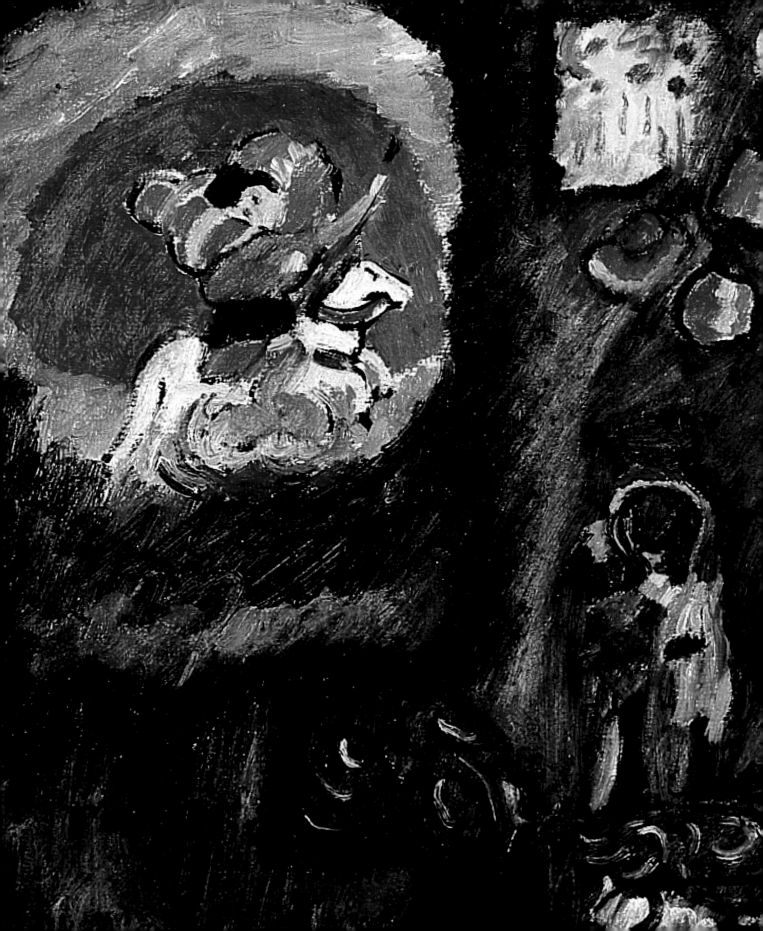

The Life and Work of Gabriele Münter

Annegret Hoberg

Gabriele Münter, Wassily Kandinsky's companion in life and like him one of the co-founders of the artists' group *Der Blaue Reiter* (The Blue Rider), is the best-known female exponent of German Expressionist painting. In the years leading up to the First World War she, together with her fellow artists in the *Blaue Reiter* movement in Munich and the small Bavarian town of Murnau, helped achieve a breakthrough for a new type of painting notable for its intense colouring, bold formal simplification and powerful expression. What follows is an overview of the main emphases of her creative work.

Gabriele Münter was born in Berlin on 19 February 1877, the youngest of the four children of the dentist Carl Münter. Soon after her birth the family moved to Westphalia, the region her father originally came from. Münter's parents, who by that time were no longer young, had met in America. Her father had emigrated there as early as 1848, while Münter's mother, the daughter of a German cabinetmaker, had lived in the United States since her childhood. Münter's father died while she was still attending school in Koblenz, and in 1897, when she was twenty years old and living at home without an occupation, her mother died, too. After a brief period studying drawing at a private school in Düsseldorf, in 1898 Münter set out with her elder sister Emmy on an extended trip to visit relatives in America. Orphaned of both parents, enjoying a certain inherited wealth, they were completely independent. They stayed in the United States for over two years, mainly in Texas, Arkansas and Missouri, returning to Germany in the autumn of 1900. The relatively free, unrestricted life Münter had led in her youth, largely unconstrained by convention, then her experience in America of the pre-dominantly rural, 'Pioneer' life of her relatives, no doubt gave Münter a range of social exposure unusual for a young woman of her time.[1] On the one hand she became used to greater independence than most of her social equals, but on the other, given the circumstances of her early life, she must also have developed an extreme need for closeness and attention.

In the spring of 1901 Münter continued her art studies in Munich, where she entered the beginner's class taught by Maximilian Dasio at the school of the *Künstlerinnenverein* (Association of Women Artists). Public art academies were still closed to women at that time. Then in the winter of 1901 a fellow student of Münter's told her about the newly founded *Phalanx* art school, run by Kandinsky and Wilhelm Hüsgen. This small private art school had been founded in May 1901 on the initiative of Kandinsky, the sculptor Hüsgen and other progressive figures on the art scene active in the Schwabing district of Munich. Soon afterwards Kandinsky became president of the

Still Life with St George
(detail of fig. 13)

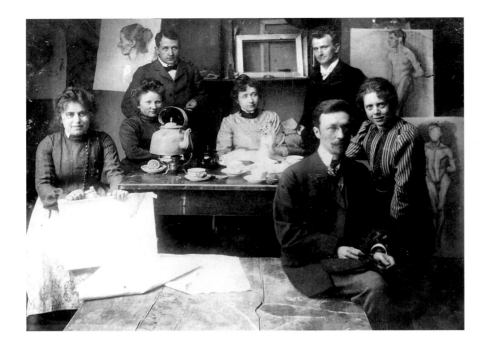

Phalanx, and organized several major exhibitions as well as teaching painting at the school. He had arrived in Munich from his home city of Moscow a few years earlier, a qualified lawyer, thirty years old, determined to devote himself entirely to painting. After an unsatisfactory period of study at the studio of Anton Azbé – where, however, he had made the acquaintance of his compatriot Alexej Jawlensky and of Marianne Werefkin – and a year at the Academy studying under Franz von Stuck, he had decided, although still completely unknown and dependent on his own resources, to found an alternative school of art, the Phalanx, as the 'spearhead of a new art'.[2] Münter, who was also dissatisfied with traditional teaching methods, attended Kandinsky's drawing class – an evening life-drawing class – and for the first time found in him a teacher who took her seriously: 'The way in which K.[andinsky] – in quite a different way from the other teachers – explained things painstakingly and thoroughly and regarded me as a consciously striving human being was a new artistic experience', she wrote in her memoirs. 'It was new to me and it made an impression. – Apart from that, it was very pleasant up there on the 3rd floor of the Phalanx school on Hohenzollernstrasse' (fig. 1).[3]

In the summer of 1902 Münter accepted an invitation from Kandinsky to join his summer painting class at Kochel, south of Munich in the foothills of the Alps. Thus began a tender relationship between teacher and pupil. Soon Kandinsky's feelings for Münter must have become so strong that, out of consideration for his wife, his Russian cousin Anja Semjakina, who was also with the class, he asked her to interrupt her stay in Kochel for the time being. Münter acceded to this request with a little reluctance; and it would not be the last time that she subordinated her artistic development to the circumstances of her private life. But back in Munich that autumn Kandinsky's

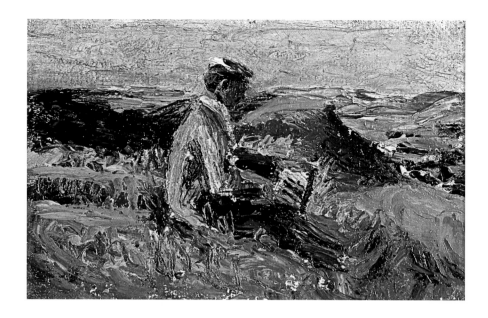

Fig. 2 Gabriele Münter,
*Kandinsky painting a
Landscape (Kandinsky beim
Landschaftsmalen)*, 1903
Oil on board, 15 × 25 cm
Städtische Galerie im
Lenbachhaus, Munich

attentions continued, as is demonstrated by, among other things, more than
thirty-five letters he wrote to Münter before the end of the year. However,
there also appeared the first signs of tension between them, because Münter
was unwilling to accept keeping things secret from Kandinsky's wife. In the
summer of 1903, after some hesitation, she decided to take part again in a
painting course for Kandinsky's Phalanx class, based this time in Kallmünz in
Oberpfalz, the northern part of Bavaria. Up until then Münter had produced
almost exclusively drawings, but there she painted quite a number of small
oil studies, in the Post-Impressionist pastose palette-knife technique which
Kandinsky had taught her. Her small picture *Kandinsky painting a Landscape
(Kandinsky beim Landschaftsmalen*; fig. 2) shows her companion sitting on the
meadow high up on the Schloßberg above Kallmünz, looking somewhat stiff
in a suit, with one of the small-format painting boards that artists then used
for their outdoor oil studies in his hand. That summer in Kallmünz Kandinsky
and Münter became intimate; Kandinsky had previously spoken to his wife,
who released him on amicable terms. After this time together Münter again
spent long months with her brothers and sisters in Bonn, before eventually
moving into a small studio flat of her own for the first time at the end of
1903, at the Siegestor in Schwabing. But Kandinsky wanted to get away from
the difficulties of his private situation and insisted on a trial period together
as far away as possible from Munich and from his wife, to whom he felt
bound in a way that went far beyond the conventional limits of propriety.

For these purely private reasons, and not for any such purpose as artistic
development, in May 1904 the couple now embarked on an unsettled itinerant
life that was to continue for four years. After travelling to Holland in the
winter of 1904, the couple set off on a journey to Tunis lasting several months,
only returning to Munich via Italy in April 1905. During the cold winter
in Tunis Münter produced relatively few pictures – a few street scenes in

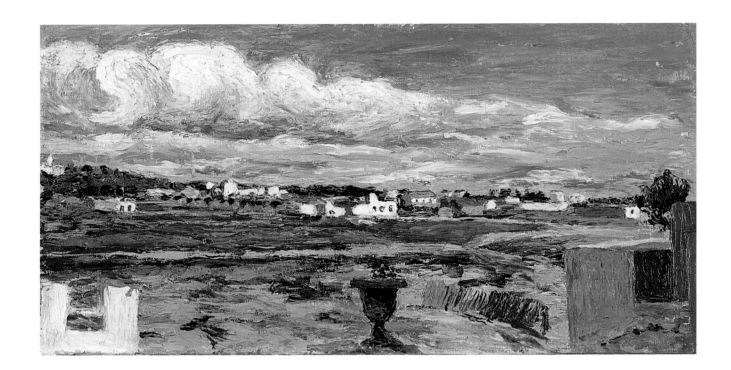

Fig. 3 Gabriele Münter, *Tunisian Landscape* (*Tunislandschaft*), 1905
Oil on board, 29 × 44 cm
Private collection

tempera, or small-format landscapes such as the view from the roof of her hotel in the outskirts of the city (fig. 3). In these years of travelling no great changes can be noted in the painting style either of Münter or of Kandinsky; both continued to paint landscape motifs in a carefully dabbed palette-knife technique, which in Münter's work in particular still retains a great deal of the atmospheric spatial recession characteristic of more academic naturalism.

The couple spent the summer of 1905 together in Dresden, and in the winter they travelled via Milan to Rapallo on the Amalfi coast, where they remained for almost six months. Then in May 1906 they moved on to Paris and settled in the Parisian suburb of Sèvres for a whole year. Tensions in their relationship led Münter temporarily to live alone in a room in Paris that winter, attending a course in drawing at the *Académie Grande Chaumière*, where her clearly structured works were praised by the well-known poster artist Théophile Steinlen in particular. In Paris she concentrated especially on the coloured-woodcut technique which she had learnt during her stay in Kallmünz, achieving a rapid and remarkable mastery in it. While she had previously been influenced by Munich *Jugendstil* (Art Nouveau), in Paris she was directly inspired by the new style of French woodcut, which had brought about a revival of this older technique at the beginning of the modern period; with its requirements of extreme simplification of form and flat representation it made a considerable contribution towards undermining the traditional laws of picture-making – illusionism, accuracy of detail, perspective.[4] Almost all the woodcuts and linocuts Münter made in Paris exist in various colour states and display the firm structure and assured outline that are also always characteristic of her drawings. In the exquisite portrait of her landlady, *Mme*

Fig. 4 Gabriele Münter, *Mme Vernot with Aurélie* (*Madame Vernot mit Aurélie*), 1906
Coloured linocut, 17.8 × 12.2 cm
Städtische Galerie im Lenbachhaus, Munich

Vernot with Aurélie (*Madame Vernot mit Aurélie*; fig. 4), she further experiments with states in which the foreground and background are coloured and cut in different ways, while the housemaid is glimpsed very much diminished like a spectre in the kitchen.

In her painting she still lacked the sureness as well as the revolutionary approach of her graphic technique: *View from the Window in Sèvres* (*Blick aus dem Fenster in Sèvres*; fig. 5), painted in the winter of 1906, shows that she – like Kandinsky, too, in his *plein-air* pictures – had not moved on from the late Impressionist style of their years of travelling, and ultimately they both felt that they were at an artistic impasse in Paris. After returning from Paris in the summer of 1907 Münter and Kandinsky spent the winter months in Berlin, and finally in the spring of 1908 they travelled to South Tyrol.

By the time they returned to Munich from their travels in June 1908, they had reached the decision that they would at last settle there permanently again, and therefore set about looking for an attractive place to paint in the

Fig. 5 Gabriele Münter, *View from the Window in Sèvres* (*Blick aus dem Fenster in Sèvres*), 1906
Oil on canvas, 38 × 46 cm
Städtische Galerie im Lenbachhaus, Munich

surrounding area. On one of their trips south of Munich they discovered the old town of Murnau on the Staffelsee (Lake Staffel) in the foothills of the Bavarian Alps near Garmisch-Partenkirchen. Enchanted by its picturesque position on the edge of the extensive Murnau moors – still today one of the largest stretches of moorland in Europe – against the imposing backdrop of the Alps, they told their painter friends Alexej Jawlensky and Marianne Werefkin about it, and all four met up in Murnau a short time later and booked accommodation at the Griesbräu Inn on the Obere Hauptstraße (fig. 6).

The weeks spent painting together that now followed during the beautiful late summer from mid August to the end of September 1908 were to be a turning point in their personal lives and their artistic development. Murnau 1908 is a place and date of crucial significance for German Expressionist painting: it marked the birth of *Der Blaue Reiter* and hence the epoch-making breakthrough to modern painting – in Kandinsky's case, to abstract painting, too. Along with the artist's group *Brücke*, founded in Dresden in 1905 and relocated to Berlin in 1911, *Der Blaue Reiter* became the most important movement of artistic innovation in Germany in the early twentieth century. In Murnau both Kandinsky and Münter rapidly discovered a new means of painterly expression, something they had long been seeking. The intense light in the foothills of the Alps, which often brought out the colours and contours of the landscape and the village in clear planes with very little atmospheric refraction, contributed to an emancipation of their vision. With a previously unseen fluent, spontaneous touch – both quickly changed over from the palette knife to using the brush – they created first views of the village, then soon of the surrounding area, too, of the Murnau Moors and the chain of mountains, in powerful, bright colours. Kandinsky's *View from the Window of the Griesbräu (Blick aus dem Fenster des Griesbräu*; fig. 6) was one of the first pictures to be produced during their stay in Murnau and, like Münter's

Fisherman's House (*Fischerhaus*; fig. 7) painted a short time later, it already showed the essential characteristics of their change of style – simple forms and outlines, powerful, unmixed colours, a reduction of perspective in favour of surface, and an increasing simplification of objects to heighten expressivity. In Münter's *View of the Murnau Moors* (cat. 5) a colourfulness and simplicity of pictorial means, bold for the artistic sensibility of the time, are again dominant: purple and blue are found here beside unmodelled green hues; inserted without atmospheric refraction, the basic elements of the landscape are separated one from another by simple black lines, and in places the untreated ground of the painting board shows through. Münter's great artistic strengths, the intensity of her gaze and her capacity to simplify what she had actually seen, developed fully in Murnau and attracted the admiration of her friends, at times becoming an inspiring model for them. During those weeks she showed a tremendous enthusiasm for work, painting up to five oil studies a day in the open air; in a diary written three years later she succinctly sums up the decisive break-through of her painting in words that would be quoted frequently thereafter: 'After a short period of agony, I made a great leap – from copying from nature, in a more or less Impressionist style, to feeling the content of things – abstracting – conveying an extract'.[5] In her writing she specifically mentions her beneficent, stimulating collaboration with Jawlensky. He was the only one of the four friends who had a professional grounding in French avant-garde painting behind him, having spent two periods in France in 1905 and 1907, and he now passed on his knowledge of the art of Henri Matisse, Paul Gauguin and the Nabis group to his fellow painters in Murnau. In her pictures Münter particularly adopted his technique of composing the objects in the picture in largish, coloured surfaces and surrounding them with narrow dark outlines in order to fix the individual elements together in an expressive 'synthesis'. Thus the oil study *View of the Murnau Moors* mentioned above is unmistakably related to contemporaneous paintings by Jawlensky, such as his *Summer Evening in Murnau* (*Sommerabend in Murnau*; fig. 8).

While still in Murnau that autumn Kandinsky finally rented a flat of his own in Munich, on Ainmillerstraße in Schwabing, so preparing, albeit still with some hesitation, to set up a joint household with Münter. However, after their return to the city together Münter continued to live at a boarding-house in Schwabing for another year, with a studio a few houses away from her lodgings.

The next year, 1909, was another period of intensive activity in Murnau for the couple, spent partly together with their friends. They were there again in

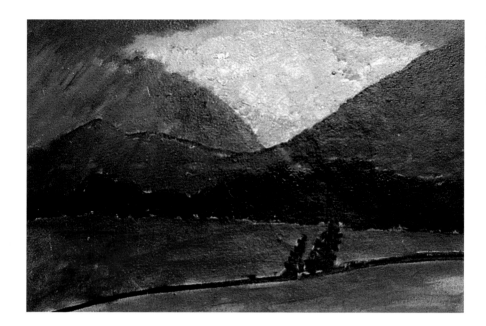

Fig. 8 Alexej Jawlensky,
Summer Evening in Murnau
(*Sommerabend in Murnau*),
1908
Oil on board, 33.2 × 45.1 cm
Städtische Galerie im
Lenbachhaus, Munich

the spring with Alexej Jawlensky and Marianne Werefkin, at first living
in private lodgings. Two of Münter's most famous pictures, *Jawlensky and
Werefkin* (cat. 9) and *Portrait of Marianne Werefkin*; fig. 33, p. 61), were among
the works painted early that summer.[6] Radical formal simplification and clear,
forceful colour contrasts characterize Münter's picture of the couple on the
meadow. The figures appear only as simple, basic forms and are framed tersely
and deftly by powerful, dark contour-lines. Here Münter is clearly continuing
to develop the Post-Impressionist technique of *cloisonnisme*, derived from Paul
Gauguin and imparted to her by Alexej Jawlensky. The *Portrait of Marianne
Werefkin* was painted during the same period – Werefkin is even wearing
the same hat as on the meadow – and it stands out among Münter's portraits
for its lively radiance, positive energy and painterly verve. Now, as in *House
with Apple Tree* (*Haus mit Apfelbaum*; fig. 9), Münter was simplifying and
heightening her new expressive technique of painting in her own way, turning
it into an intensive, almost abstractive way of looking, which nevertheless
did not abandon the object, but condensed it and endowed it with a reality all
of its own, using her 'swaying line' and strong 'colour sense', as Kandinsky
wrote of Münter.

In the course of that summer of 1909 Münter decided to buy a house in
Murnau, spurred on enthusiastically by Kandinsky – a small, simple *Jugendstil*
villa which had just been built on a hill opposite the old town centre (fig. 10).[7]
This house purchase by Münter later reinforced one of the many myths
regarding her relationship with Kandinsky – namely the view that Kandinsky
as a 'homeless Russian' had lived at her expense. However, in the years before
the First World War and during their time together, both lived off a kind of
life annuity paid from their family property; it was not lavish in either case.
While the inheritance of Münter, who had lost both her parents, was admin-
istered by her brother in Bonn, Kandinsky received income from renting out

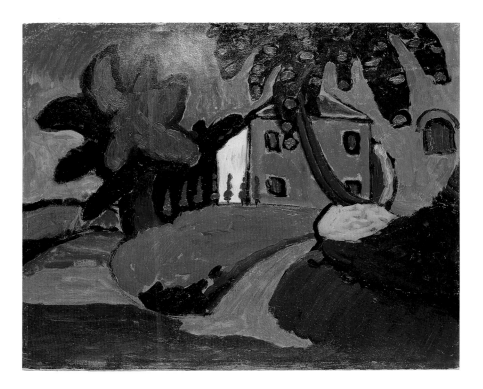

a house he owned in Moscow as well as intermittent subsidies from his separated parents; his father was the director of a tea-trading company. From 1912 on, for Kandinsky there was also an increasing income from the sale of his pictures, whereas in her own lifetime Münter sold only a handful – one reason why relatively few of her works are now held in museums. In 1913 Kandinsky sold his house in Moscow and bought a plot of land on which to build a large block of flats for rent; the story of his deriving almost no further profit from it, his difficulties in the war years in finding anywhere in Moscow to stay himself, and ultimately his loss of his property in the Russian

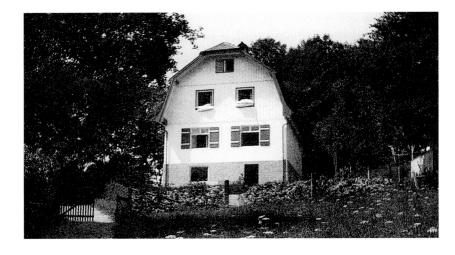

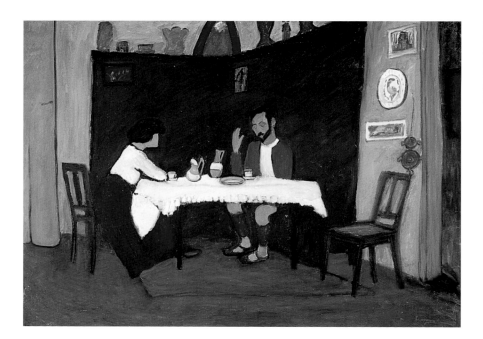

Fig. 11 Gabriele Münter,
*Kandinsky and Erma Bossi at
the Table (Kandinsky und Erma
Bossi am Tisch)*, 1912
Oil on canvas, 95 × 125.5 cm
Städtische Galerie im
Lenbachhaus, Munich

Revolution, is told elsewhere. For Münter, who later got into considerable financial difficulties, too, as a result of the war, inflation and her dwindling inheritance, the house in Murnau ultimately became home.

In her years with Kandinsky, the two furnished and decorated the house with great enthusiasm, setting the garden to rights, painting the furniture sometimes with their own paintings following simple traditional patterns, and decorating the walls and tables with religious folk art and regional handicrafts. Another important influence came along during their time in Murnau in 1909, giving new inspiration to their creative work – their discovery of Bavarian and Bohemian *Hinterglasmalerei*, or glass painted on the reverse. Sharing in the trend towards primitive art which could be observed in many places among the European avant-garde at the beginning of the twentieth century, the artists of the budding *Blaue Reiter* movement discovered for themselves the folk art of *Hinterglasmalerei*. According to Münter's recollection, Jawlensky was the first of the friends to draw attention to the large collection of more than a thousand pictures on glass belonging to a Murnau brewer, which is now in the Oberammergau Heimatmuseum. Münter was ahead of all the others in starting first to copy the traditional patterns of works of this kind, and then to learn the technique from a traditional glass painter still active in Murnau at the time.[8] Soon she and Kandinsky were creating pictures on glass after their own designs, as also Franz Marc, August Macke and Heinrich Campendonk would do later. As well as their luminous, pure colours and simple black contours it was the direct, naïve nature of their representations and the soulfulness of the feeling in both *Hinterglasmalerei* and votive images that fascinated the artists. Even for Kandinsky these simple forms were not in opposition to the 'great realistic', as he called it, but analogous to the 'great abstraction' that swam before his eyes.

Fig. 12 Folk-art objects from
the estate of Gabriele Münter
and Wassily Kandinsky
Gabriele Münter- und Johannes
Eichner-Stiftung, Munich

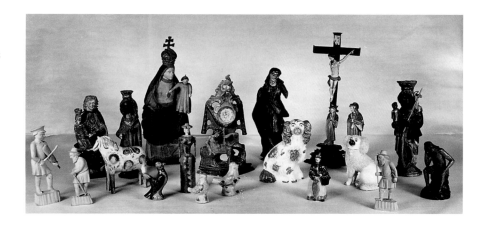

Before long the interiors of their house in Murnau and their flat in Munich
reflected Münter's and Kandinsky's great enthusiasm and fondness for folk
art. Even in Münter's well-known painting of *Kandinsky and Erma Bossi at
the Table* (*Kandinsky und Erma Bossi am Tisch*; fig. 11), in which she recorded a
conversation taking place between Kandinsky and a fellow woman-painter in
the dining area of the house at Murnau, a few paintings on glass are hanging
on the wall and simple objects and figurines can be seen on the shelf. A number
of them, mainly carved Madonnas and shepherd figures and clay animals, are
still preserved in the estates of Gabriele Münter and Wassily Kandinsky (fig. 12).
In this Murnau interior Kandinsky, dressed in the local Bavarian costume,
is delivering a lecture with his hand upraised, while Erma Bossi is leaning
forward and listening to him intently. Münter depicts the space and the
relationship between the figures in succinct outlines and sweeping geometric
forms; most attention is concentrated on Kandinsky's bright blue jacket, his
light-blue spectacle lenses and his raised hand. In her picture of this animated
conversation – or perhaps more of a lecture – Münter captures something
of the atmosphere of lively discussion of these years with a sure touch and
gentle comedy.

Meanwhile the *Neue Künstlervereinigung München* (Munich New Artists'
Association) had been founded in January 1909, in a climate characterized by
fruitful reciprocal exchange, collaboration in Murnau and frequent discussions
about art at the Munich flat of Jawlensky and Werefkin on Giselastraße
in Schwabing. Besides the four friends, its members included Erma Bossi,
Adolf Erbslöh, Alexander Kanoldt, Vladimir von Bechtejeff, David and
Vladimir Burljuk, Alfred Kubin and the dancer Alexander Sacharoff. The
Neue Künstlervereinigung München, or NKVM, was the forerunner of *Der
Blaue Reiter*. Its activities included the organization of three major exhibi-
tions, the last of which, held three years later in late 1911, was to occasion
the break-up of the group and the founding of *Der Blaue Reiter*. Münter's
portrait of Jawlensky entitled *Listening* (cat. 10) again uses a strikingly simple
formula to express something of the atmosphere of animated discussion in
a witty and pointed way. In greatly simplified forms, she shows her friend
and fellow artist with his round bullet head and equally round pale blue
eyes listening to Kandinsky's theories, obviously with some bewilderment.[9]

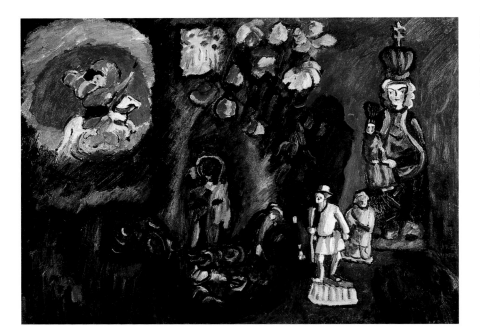

Fig. 13 Gabriele Münter,
Still Life with St George
(*Stilleben mit Heiligem Georg*),
1911
Oil on board, 51.1 × 68 cm
Städtische Galerie im
Lenbachhaus, Munich

During this period Münter's portraiture was usually inspired more by a characteristic situation than by the detailed physiognomy of the person depicted – and yet in her pictures of her friends she was the only portrait painter and chronicler of the group of artists.

Still life was another genre which Münter studied intensely – the only member of the group apart from Jawlensky to do so – and in the very productive years around 1909–11 she contributed significantly to it. The small but very expressive folk-art objects which she and Kandinsky collected so passionately now began to find their way into her still lifes, giving them a quite particular, personal and at the same time 'spiritual' aura. The artist's large still-lifes of 1911 are a high point of her creative work, and an important contribution to the specifically transcendent message of *Der Blaue Reiter*, the group's belief in something like the materialisation of the 'spiritual in art'. In ever new variations they explore the familiar objects of religious folk-art and popular handicrafts in her domestic surroundings, generally set against a dark, diffuse background, and in the process the figures and *Hinterglasmalerei* pictures seem to acquire an inner life and communicate with one another in a mysterious way.

Again in *Still Life with St George* (*Stilleben mit Heiligem Georg*; fig. 13) the figures seem to blend in completely with the bluish-green and purple ground, losing their real corporeality and taking on a different kind of presence. At top left St George, seated on a white horse against a blue background, defeats the dragon – it has become almost impossible to discern that we are dealing with a glass painting hanging on the wall. In the foreground we see a stoneware hen, together with small figures of shepherds from Oberammergau, a Madonna enthroned with a double crown and a smaller standing Madonna figure. The dark glow of the colours, in which a magical blue plays a special role, the silent

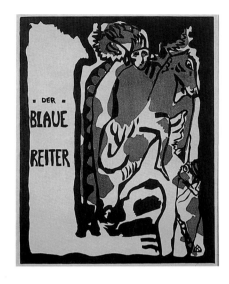

absorption of the figures, but also the distortions of the space make this still life one of the most important paintings ever made by Münter.

Only brief mention can be made of the fact that St George, who has emerged here like an emblem as a 'picture within a picture', also became the symbolic figure for *Der Blaue Reiter*. The patron saint not only of Moscow, but of Murnau too, and present in churches, on the streets and in the art of *Hinterglasmalerei*, St George was also depicted several times by Kandinsky, sometimes in large, almost abstract oil-paintings. Even for the final title-page picture of the almanac *Der Blaue Reiter* (fig. 14), which Kandinsky and Franz Marc had been planning since 1911 and eventually published in May 1912, Kandinsky chose the figure of St George, compressed into a narrow portrait format.[10] Protected by his shield and wearing strange headgear, the Christian knight and dragon-slayer, stylised in a highly individual way, sits on his high-stepping horse; beneath him winds the dragon with its scaly tail rearing up, and in the foreground on the right the small bound figure of the biblical princess looks up at her liberator. As a 'blue rider' St George was transformed into the symbol of a movement of renewal, of the overcoming and redemption of the old world, hidebound in materialism, by the purifying power of the spirit. This message of salvation promising a new epoch in which the arts of the future would have their share was announced by the almanac in many places. *Der Blaue Reiter* became the collective name of the movement when Kandinsky, Marc and their fellow travellers organized the now legendary 'First Exhibition by the Editors of *Der Blaue Reiter*' at the end of December 1911.

Things had come to a head beforehand and there had been a decisive break between the progressive and the moderate members of the NKVM. When the jury for its third exhibition at the Thannhauser gallery in Munich rejected a large-format, almost completely abstract painting on the flimsy pretext that it was too big, Kandinsky, Münter, Marc and Alfred Kubin left the association, and in a short space of time organized a rival exhibition of their own, inviting artists of their own choice, likewise held at the Thannhauser gallery. In this first *Blaue Reiter* exhibition Münter was prominently represented with six major paintings, alongside Kandinsky, Marc, August Macke, Heinrich Campendonk, Robert Delaunay, Arnold Schönberg and others.[11] The second *Blaue Reiter* exhibition followed in February–April 1912, this time showing exclusively works on paper, including some by Paul Klee, Kubin, the *Brücke* artists and the French avant-garde. With more than three hundred exhibits it, too, made history.

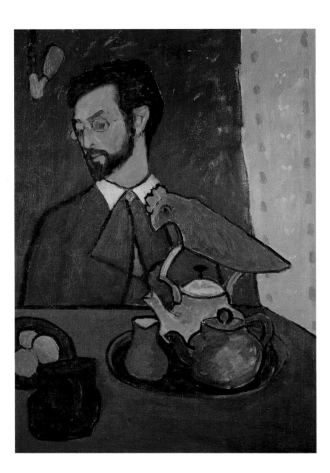

Fig. 15 Gabriele Münter,
Kandinsky at the Tea Table
(*Kandinsky am Teetisch*), 1910
Oil on board, 70 × 48.5 cm
Israel Museum, Jerusalem

However, the increased activity of this period cannot obscure the fact that from the spring of 1912 onwards there had been increasing personal tensions within the group. Nor can it be denied that they were directly linked to Münter, and had a negative impact on her productivity and enthusiasm for work. It is not possible to go into her conflicts with Macke, Marc and their wives in detail here; Münter's touchiness, no doubt occasioned by her insecurity and fluctuating self-confidence, obviously played a role in these tensions.[12] But from 1911 at the latest their correspondence also reflects a growing estrangement in her relations with Kandinsky, though outwardly he always stood up for her in these conflicts.

Dissonances, partly unconscious, are also apparent in her depiction of her partner, and can almost be interpreted as aversion and hostility. In the picture *Man at the Table (Kandinsky)* (*Mann am Tisch (Kandinsky)*; cat. 16), painted during Easter 1911, the narrow, contracted figure of Kandinsky is sitting with folded arms, consigned to the background. Nevertheless, in spite of the smudged facial features, he seems to be staring attentively at the viewer – or the painter. His aloof attitude, sitting beside the leaves of a plant spreading out wide as if to ward people off, gives the impression of disharmony. Again in *Kandinsky at the Tea Table* (*Kandinsky am Teetisch*; fig. 15), painted a full year earlier, the narrow figure of her companion with his face averted to the side

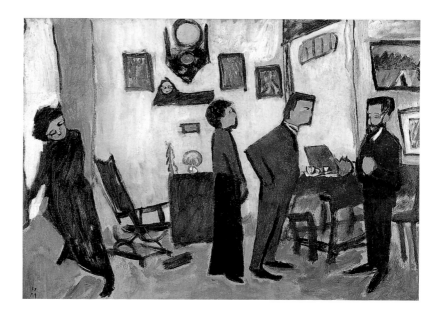

Fig. 16 Gabriele Münter, *After Tea II (Nach dem Tee II)*, 1912
Oil on board, 51 × 68 cm
Private collection

shows a similarly defensive attitude. Yet Kandinsky himself very much appreciated the *Man at the Table* because of its raw, uncompromising depiction of him, and even had it reproduced in the almanac *Der Blaue Reiter*.

In 1911 Kandinsky obtained his divorce; because it was decreed according to the Greek Orthodox rite, but no doubt also because of Kandinsky's lack of vigour in pursuing it, the divorce proceedings had dragged on for an unusually long time. Münter naturally hoped for marriage and had already made repeated references to it in many of her letters. But in 1911–12 the mutual tensions and disappointments tended to become more acute. What is certain is that Münter's pace of work perceptibly slackened from 1912 on. While from 1911 to 1914 Kandinsky was finding his way towards abstraction with his large *Impressions*, *Improvisations* and *Compositions*, by 1914 she was painting considerably less than in the years since the breakthrough in 1908. In addition the pictures she was producing were frequently characterized by a restlessly vibrating brushstroke; colour and line were ever more divergent, and her characteristic black contours often became independent graphic signs. In the conflict-ridden month of April 1912 she took the visit of the art dealer Hans Goltz and his wife to the flat she and Kandinsky shared in Ainmillerstraße as the subject for a picture (fig. 16). There are no fewer than eight large-format drawings and two other oil versions of this picture, known as *After Tea II (Nach dem Tee II)*; Münter circles round the theme, obviously having difficulty with the composition and remaining dissatisfied with it. In the studies she repeatedly alters in particular her own position in the room, sitting in dark clothes and isolated on the left in the window recess; generally they show the two men standing further to the right in animated discussion. The American Münter scholar Reinhold Heller has convincingly demonstrated that this series of pictures can be interpreted as an expression of Münter's personal and artistic crisis. 'Münter's drawings for *After Tea* are preoccupied with finding pictorial expression for this personal alienation,' Heller writes. 'At the

same time they show a social division of men and women into their own separate groups, a psychological one, too, through the fact that the two men are talking animatedly, while the two women are sitting there in silence, not participating [. . .] Such a strong dissatisfaction flared up in the pictures that Münter could still remember it more than forty years later.' In the end she transformed the subject into an almost completely non-objective composition with black lattice work, one of the few abstract pictures by Münter from this period. Heller has written: 'In exploring them in the pictures she acted out the conflicts of her worsening relationship with Kandinsky, her dissatisfaction and fear.' The outcome was the switch to abstraction, for 'with a subject that was laden with conflicts in the imagination, the memory was unable to come up with a well-thought-through, settled image'.[13]

It is not possible here to go into detail regarding Gabriele's complicated, tricky relationship with Kandinsky in these final years they spent together. Just a few days after the outbreak of the First World War on 1 August 1914, when Kandinsky, as a Russian, ceased to be welcome in Germany, becoming an 'enemy alien', he and Münter emigrated to Switzerland, first to Rorschach on Lake Constance, then to Zurich. Here they separated in November 1914, Kandinsky returning to his native Moscow. Before leaving he had suggested to Münter that they should no longer live together, but still continue to meet as friends. He repeated this proposal in a series of letters that soon followed from Russia, reacting to Münter's ever more insistent requests that they should see one another again. Münter for her part returned to Munich from Zurich at the beginning of 1915, but soon, full of impatience, she gave up the flat in Schwabing, closed the house in Murnau and in May travelled to Stockholm via Berlin to meet up with Kandinsky on neutral foreign soil. She had extracted this promise from him before he left Zurich. However, Kandinsky did not join her in Stockholm until December 1915, after long hesitation. They stayed there until March 1916, and this was to be the last period the couple spent together.[14] The fact that Kandinsky did not have the courage to make the break final at this last meeting, but on the contrary promised his importunate companion that he would return, shows shameful weakness on his part. As we know, in 1917, the year of the Russian Revolution, he married the young Russian Nina Andrejewska, who was just seventeen years old, and stopped writing to Münter. She believed that he had gone missing in the turmoil of the Revolution, and did not learn of his whereabouts and his marriage until several years later.

Although the years she spent in Stockholm until 1917 were overshadowed

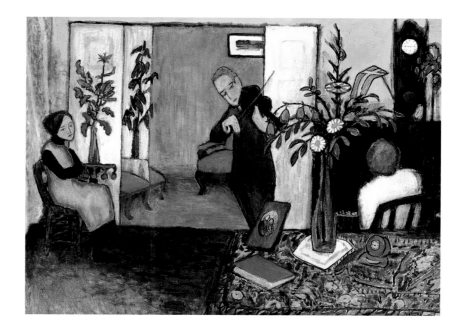

Fig. 17 Gabriele Münter, *Music* (*Musik*), 1916
Oil on canvas, 90 × 114 cm
Private collection

Fig. 18 Gabriele Münter,
Poster for the Gabriele Münter
exhibition, *Den Frie Udstilling*,
Copenhagen, 1918
Colour lithograph, 87 × 62 cm
Städtische Galerie im
Lenbachhaus, Munich

for Münter by her difficult relationship with Kandinsky, she nonetheless quickly made contact with avant-garde artistic life in Sweden, and until she moved to Copenhagen her work could be seen at several solo and group exhibitions in the Swedish capital. In particular her contacts with the most prominent couple in the avant-garde there, Sigrid Hjertén and Isaac Grünewald, pupils of Matisse and founders of Swedish Expressionism, left clear traces in Münter's work.[15] Thus in her painting *Music* (*Musik*; fig. 17) of 1916, large parts of the picture are in cool mixed colours, yellow-green, pink and grey, with the blue of the Swedish flag and the red of the clock and book introducing more powerful accents only in the right half of the picture. Narrow, angularly broken contours surround the quietly introspective figures. The novelty of the almost cool and artificial choice of colours and their thin application – in contrast to the pure, powerful and often pastose colours of Münter's pictures from the *Blaue Reiter* period – and the decorative conception of the figures clearly show the influence of the interior scenes of Sigrid Hjertén, who had been taught by Henri Matisse.

The large painting *Reflection* (*Sinnende*; cat. 21) of 1917, with its elegant yet melancholy conception of the figure, sophisticated colour combinations and ornamental treatment of space, shows a stylistic closeness to Hjertén's pictures from the same period. But at the same time this symbolic figure portrait by Münter has a penetration and moodiness that have few parallels in modern art. A young Jewess, Gertrude Holz, served as her model here as well as in other works by Münter in which she depicts female figures that simultaneously convey psychological states of waiting, hoping, thinking or suffering, as in the pictures entitled *Future* (*Zukunft*), *At the Clockmaker's* (*Beim Uhrmacher*) or *Sick* (*Krank*).

However, Münter's external successes in Stockholm cannot obscure the fact that her stay there ended in late 1917 in loneliness and depression. She

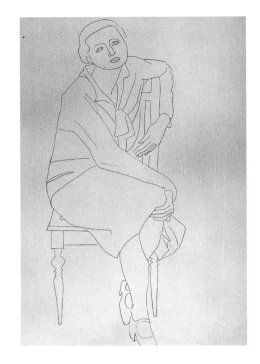

moved to the Danish capital, Copenhagen, hoping that there, too, she would be able to latch on to the reputation of the *Sturm* artists of the Berlin gallery owner Herwarth Walden, who at that time represented her and also temporarily Kandinsky. Indeed in the spring of 1918 she held what was her largest solo exhibition to date in *Den Frie Udstilling*, with over 100 works. For the poster (fig. 18) she chose to recall her painting *Music* (fig. 17), the motif of a violinist and a woman seated on the right imparting a similar mood of longing and isolation. Here again, the small china dog in the middle of the picture, which Münter had brought with her from Murnau and which crops up in many of her still lifes, and the mountains on the far shore of the sea, possibly a reminder of Bavaria, suggest a personal, psychological interpretation in which memory and melancholy are mingled.

Münter lived in Denmark, mostly in Copenhagen, in great isolation for another three years, until the beginning of 1920. Her artistic output dried up almost completely, and in addition, as a result of wartime inflation in Germany, she experienced great financial difficulties, so that she had to live in extremely straitened material circumstances.

Only a much briefer outline of Münter's creative work in the second half of her life will be given here. After her return to her house in Murnau in the spring of 1920 Münter's loneliness and depression continued for another five long years. In 1920 she also learnt through a friend of Herwarth Walden that Kandinsky was still alive and had got married in Moscow. In 1921 she heard further that he would be returning to Germany with his wife, having been appointed by Walter Gropius a professor at the Bauhaus in Weimar; the couple arrived there at the end of the year exhausted, and in impoverished circumstances. We can only begin to imagine the impact this news had on Münter.

Admittedly from 1922 she had again started to produce a number of drawings, and in 1924 some oil paintings, too, but life and work were still characterised for her by pain and lethargy. In 1925 she could finally bear the isolation in Murnau no longer; she shut up her house and travelled to Berlin via Cologne, where she again made some connection with artistic life, finding contacts especially in the circle of avant-garde women artists and writers there. In her Berlin years up to 1928 she produced a large number of pencil drawings, almost exclusively of female sitters; with their inimitably concise, fluently drawn contours, they express the essence of the person portrayed. These drawings by Münter, works of pure outline, without internal modelling, have often been compared with the linear art of Henri Matisse or Olaf

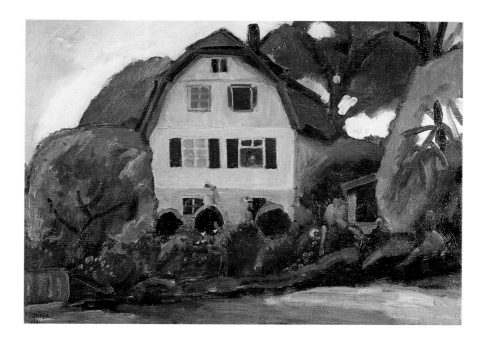

Fig. 20 Gabriele Münter,
The Russians' House
(*Das Russen-Haus*), 1931
Oil on canvas, 42.5 × 57 cm
Städtische Galerie im
Lenbachhaus, Munich

Gulbransson, and rightly so.[16] The succinct drawing of a woman sitting on a chair (fig. 19) is shown here as a specimen of hundreds of similar portraits of women's heads or full-length portraits.

At a small New Year's Eve party in Berlin in 1927, when Münter was almost fifty-one years old, she met the art historian and lecturer Johannes Eichner. After another three years of cautious friendship, Eichner became her second partner, though never in as passionate a way as Kandinsky. In the autumn of 1930, after a trip together to France which gave her new ideas for painting, she again settled permanently in Murnau and began to restore order to her house there, abandoned and neglected for so long.[17] Some time later Johannes Eichner moved in with her in Murnau. A picture of her house, then still known locally as 'the Russians' House', painted in 1931 reflects Münter's reawakened enjoyment in her art as well as her creative power (fig. 20). In the many paintings she produced in the early 1930s she quite clearly refers back to her pre-war style, to the period of *Der Blaue Reiter*; but the forms are softer, more homogeneous, less expressive. Often she again uses powerful, darkly luminous colours, which are applied flat and edged with dark contours, as in the technique of *Hinterglasmalerei*.

In view of increasing repression by the National Socialists, including the persecution of modernist art, Eichner advised Münter to adapt her style. From the end of the 1930s and in the war years Münter put her efforts into realistic painting, in particular still lifes of flowers or inoffensive portraits of the people of Murnau, made in return for money or in exchange for food. Münter and Eichner spent the Second World War in Murnau in extreme seclusion and in financially reduced circumstances. After the war Münter reconnected with moderate forms of modernism, also experimenting with the abstract tendencies of post-war painting.

Before assessing Münter's impact one further important circumstance has to be mentioned, inseparably linked to her shared past with Kandinsky. From 1924 onwards there had been a legal dispute between her and Kandinsky over the pictures and personal belongings he had left behind in Munich; it dragged on for many years. For Münter it was not so much a question of material compensation, but of moral amends. In the end some pictures were returned to Kandinsky, but the majority remained in store at a Munich warehouse, with Münter bearing the costs over many years.[18] After 1933, when the political situation was becoming ever more uncertain and condemnations of modern art were increasing, she arranged for the valuable collection of pictures by Kandinsky and other friends from *Der Blaue Reiter*, by Marc, Macke, Jawlensky, Klee and others, to be transported to her house in Murnau, where she hid them. All through the Nazi period and the Second World War Münter preserved this treasure trove of pictures with exemplary loyalty, in spite of great privation and financial hardship. Nor was her treasure shut away in the cellar discovered in the course of several house searches by the American occupying forces in 1945. Meanwhile her erstwhile companion Kandinsky had had to leave the Bauhaus in Dessau in 1933 because of persecution by the regime and had emigrated to Neuilly-sur-Seine near Paris, where he died in 1944. When the director of the Städtische Galerie im Lenbachhaus in Munich made contact with Münter in the 1950s, he only gradually discovered what an incredible collection of pictures of the *Blaue Reiter* group she owned, including more than eighty oil paintings and 330 drawings by Kandinsky alone. On the occasion of her eightieth birthday in February 1957 Gabriele Münter donated her priceless picture collection to the Städtische Galerie im Lenbachhaus in Munich, and with this noble gift made one of the most generous donations in recent museum history. In addition, in 1966, when the Gabriele Münter and Johannes Eichner Foundation was created, in accordance with her testamentary wishes, an institution was set up that not only administers her extensive personal estate, but has also developed into an important centre of research into her art and that of the *Blaue Reiter* movement.

TRANSLATED BY JUDITH HAYWARD

Notes

1 Detailed information on Gabriele Münter's American stay can be found especially in Gisela Kleine, *Gabriele Münter und Wassily Kandinsky. Biographie eines Paares*, Frankfurt 1990, pp. 58–86.

2 On Kandinsky's early years in Munich see especially *Kandinsky in Munich, 1896–1914*, exh. cat., ed. Armin Zweite, New York, Solomon R. Guggenheim Museum, and San Francisco, Museum of Modern Art, 1982.

3 See also Annegret Hoberg, 'Gabriele Münter in München und Murnau 1901–1914', in *Gabriele Münter 1877–1962*, exh. cat., ed. Annegret Hoberg and Helmut Friedel, with contributions by Shulamith Behr, Reinhold Heller, Annegret Hoberg, Annika Öhrner, Städtische Galerie im Lenbachhaus, Munich, and Schirn Kunsthalle, Frankfurt, 1992–93, pp. 28f. (Swedish: *Gabriele Münter 1877–1962. Retrospektiv*, Liljevalchs Konsthall, Stockholm, 1993). The first comprehensive retrospective exhibition illustrating Münter's artistic development, and indeed the first publication among what would be many drawing on her own diaries, letters and other writings, was Johannes Eichner, *Kandinsky und Gabriele Münter. Von Ursprüngen moderner Kunst*, Munich 1957; see especially pp. 36ff.

4 Annegret Hoberg, 'Zur Druckgraphik Gabriele Münters', in *Gabriele Münter. Das druckgraphische Werk*, exh. cat., ed. Helmut Friedel, with contributions by Annegret Hoberg, Isabelle Jansen, Margarethe Jochimsen, Brigitte Salmen und Christina Schüler, Gabriele Münter- und Johannes Eichner-Stiftung, Städtische Galerie im Lenbachhaus, Munich; August Macke Haus, Bonn; and Schlossmuseum, Murnau, 2000–01, pp. 12–13.

5 Münter's diary from 1911 is quoted at length in Annegret Hoberg, *Wassily Kandinsky und Gabriele Münter in Murnau und Kochel 1902–1914. Briefe und Erinnerungen*, Munich 1994 (3rd edn 2005), pp. 45–51.

6 Helmut Friedel, Annegret Hoberg, *The Blue Rider in the Lenbachhaus Munich*, Munich, London and New York, 2000, nos. 62, 63.

7 See further Annegret Hoberg, '"Das Russenhaus". Kandinsky in Murnau', in *Grenzgänger. Wassily Kandinsky – Maler zwischen Murnau, Moskau und Paris*, Munich (Publikation der Bayerischen Vereinsbank), 1997, pp. 42–57; and *Das Münter-Haus in Murnau*, ed. Helmut Friedel, Gabriele Münter- und Johannes Eichner-Stiftung, with texts by Helmut Friedel and Annegret Hoberg, Munich 2000; *Gabriele Münter malt Murnau. Gemälde 1908–1960 der Künstlerin des 'Blauen Reiters'*, text by Brigitte Salmen, exh. cat., Schlossmuseum, Murnau, 1996.

8 Besides the notices in the literature by Johannes Eichner and Annegret Hoberg already noted above see also *Gabriele Münter 1877–1962: Gemälde, Zeichnungen, Hinterglasbilder und Volkskunst aus ihrem Besitz*, exh. cat., ed. Rosel Gollek, Städtische Galerie im Lenbachhaus, Munich, 1977; Rosel Gollek, *Gabriele Münter. Hinterglasbilder*, Munich and Zurich 1981; *Das Münter-Haus. Hinterglasbilder, Schnitzereien und Holzspielzeug, von Gabriele Münter gesammelt, kopiert und in ihren Werken dargestellt*, ed. Helmut Friedel, Gabriele Münter- und Johannes Eichner-Stiftung, with the assistance of Nina Gockerell, Munich, 2000; and in general Ursula Glatzel, *Zur Bedeutung der Volkskunst beim Blauen Reiter*, Diss. Munich, 1975.

9 See also Eichner 1957 (as cited note 3), pp. 95f.

10 Compare Friedel and Hoberg, *The Blue Rider in the Lenbachhaus Munich*, 2000 (as note 6), no. 37. On the Almanach and its publication see in general Klaus Lankheit, *Der Blaue Reiter. Herausgegeben von Wassily Kandinsky und Franz Marc. Dokumentarische Neuausgabe von Klaus Lankheit*, Munich 1965.

11 On the early stages of the *Blaue Reiter*, its splintering from the Neue Künstlervereinigung and for the documentation of the first *Blaue Reiter* exhibition in 1911 see *Der Blaue Reiter und das Neue Bild. Von der 'Neuen Künstlervereinigung München' zum 'Blauen Reiter'*, exh. cat., ed. Annegret Hoberg and Helmut Friedel, Städtische Galerie im Lenbachhaus, Munich, 1999, especially pp. 13ff., 27ff., 315ff., 355ff.

12 Witness to the events of these months is provided by the respective artists' published correspondence, which has been much discussed: *August Macke – Franz Marc. Briefwechsel*, ed. Wolfgang Macke, Cologne 1964; *Wassily Kandinsky – Franz Marc. Briefwechsel. Mit Briefen von und an Gabriele Münter und Maria Marc*, ed. with introduction Klaus Lankheit, Munich and Zurich 1983.

13 Reinhold Heller, 'Innenräume: Erlebnis, Erinnerung und Synthese in der Kunst Gabriele Münters', in *Gabriele Münter 1877–1962* (as note 3), p. 61.

14 See further also Vivian E. Barnett, *Kandinsky and Sweden*, exh. cat., Konsthall, Malmö, and Moderna Museet, Stockholm, 1989–1990, no. 134 (Malmö), no. 231 (Moderna Museet).

15 A full treatment of Münter's artistic output in Sweden is given in Annegret Hoberg, 'Sigrid Hjertén und Gabriele Münter', in *Sigrid Hjertén – Wegbereiterin des schwedischen Expressionismus / Sigrid Hjertén – Pioneer of Swedish Expressionism*, exh. cat., ed. Katarina Borgh Bertorp, Städtische Galerie im Lenbachhaus, Munich; Käthe-Kollwitz-Museum, Berlin; and Boras Konstmuseum, Boras, 1999–2000, pp. 43–58.

16 See in the first instance Gustav Friedrich Hartlaub (ed.), *Gabriele Münter. Menschenbilder in Zeichnungen. 20 Lichtdrucktafeln. Mit einer Einführung von G. F. Hartlaub und mit einer Erinnerung der Künstlerin*, Berlin 1952.

17 On the early development of the relationship with Johannes Eichner and the artist's last years see Kleine 1990 (as note 1), pp. 546–87.

18 On the dispute with Kandinsky over the works he had left behind in Munich in 1914, the court judgement in 1926 and the division of the equity see Helmut Friedel and Marion Ackermann, 'Das bunte Leben. Die Geschichte der Sammlung von Wassily Kandinskys Werken im Lenbachhaus', in *Das bunte Leben. Wassily Kandinsky im Lenbachhaus*, ed. Vivian Endicott Barnett and Helmut Friedel, with contributions by Rudolf Wackernagel, Städtische Galerie im Lenbachhaus, Munich, 1995–96, pp. 15–31.

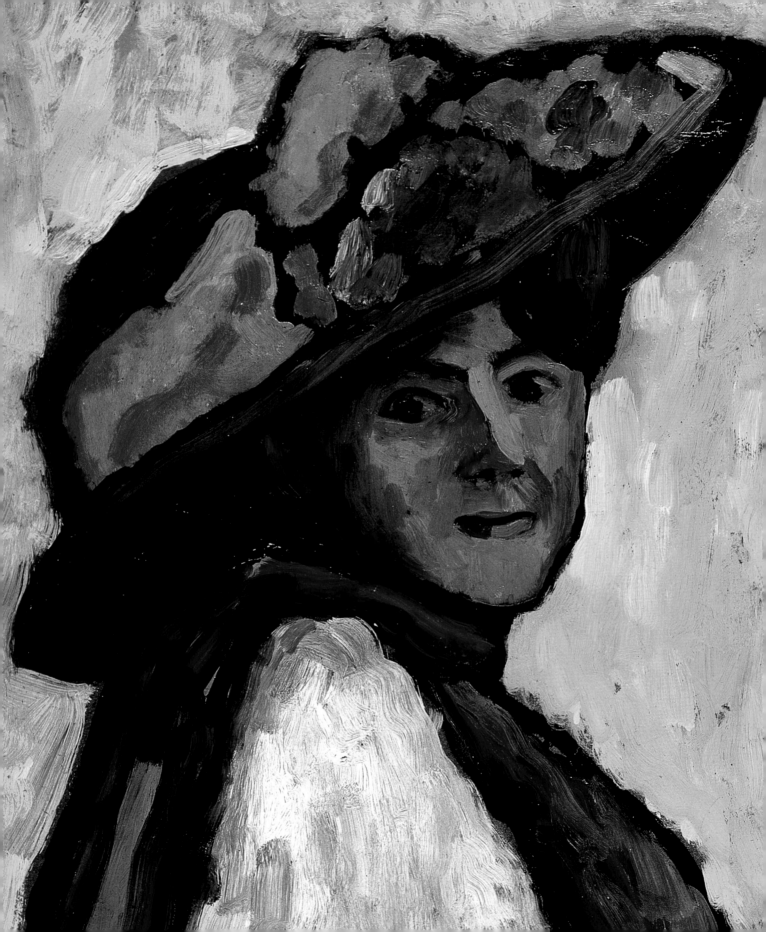

Beyond the Muse:
Gabriele Münter as *Expressionistin*

Shulamith Behr

'A few small coloured woodcuts by Gabriele Münter (park, little house, old person, bridge) are also first class, completely lovely, naïve fairy-tale poetic works full of genuine lyrical magic. It is difficult to understand how someone, succeeding in such cabinet pieces, then again in the manner of this same Gabriele Münter is able to mess about on the canvas with foolish colours and wild lines!'[1]

In December 1909, Gabriele Münter contributed the substantial number of ten paintings and eleven graphics to the launch exhibition of the *Neue Künstlervereinigung München* (Munich New Artists' Association or NKVM). Thereafter, this exhibition travelled widely in Germany, spreading the name of the NKVM further afield. In the review cited above, published in the newspaper *Münchner Post*, the art critic Hermann Eßwein responded favourably to Münter's prints, including the coloured linocut *Bridge in Chartres* (figs. 21 and 22), which is characteristic of the production of her sojourn in Paris and Sèvres in 1907. Clearly, her prints conveyed the charm of the daily routine of native inhabitants in quaint architectural settings in a manner consistent with the familiar category of *Scènes et Types* much promoted by popular photography and travel literature of the period.[2] However, Eßwein was less conciliatory towards her painting, attributing idiocy and wildness to her technical radicalism. No doubt Münter's portrait of a *Young Girl with Doll*, 1908–09 (fig. 23), one of three large-scale figural works that she exhibited, was considered provocative given the starkness of its forms, bounding contours, roughly finished surfaces and anti-naturalistic Fauvist-like coloration.

In general, reviewers of this exhibition evinced an awareness of contemporary art in Paris, their use of language evoking the scandalous reception that had given rise to the term Fauvism at the Salon d'Automne in 1905. Indeed Wassily Kandinsky, who also participated in the first NKVM exhibition, revealed details of the public hostility: 'They jab the pictures with their fingers, they employ the most forceful and impolite expressions, some even, so to speak . . . spit'.[3] However, my purpose in introducing Eßwein's review at this juncture is neither to emphasize the ambivalent reception of the artist nor to reveal prejudiced societal attitudes towards women practitioners – since the works of Münter's male colleagues attracted equal opprobrium – but to highlight the fact that cultural identity in Expressionist art and its critical discourses was not exclusively gendered male. Why then, we are led to enquire, have histories of Expressionism so rarely observed women artists'

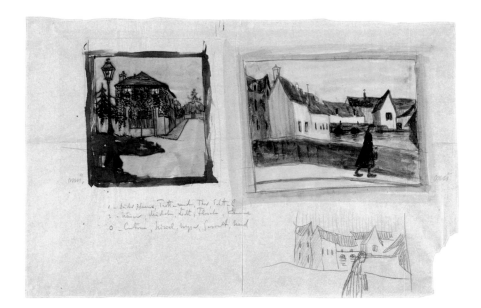

Fig. 21 Gabriele Münter,
Study for colour linocut
Bridge in Chartres (*Brücke in
Chartres*), 1907
Watercolour, black ink and
pencil, 31 × 46 cm; sketch and
notes in pencil in Kandinsky's
hand right and left
Städtische Galerie im
Lenbachhaus, Munich

participation? The excursus below addresses this question and re-evaluates
the evidence in critical reception and art historical surveys prior to 1919,
laying the ground for exploring Münter's 'different route towards Expres-
sionism'.[4] Evidently, the problematic manner in which gender is inscribed
within modernist theory and practice lies at the heart of evaluating women's
role in Expressionism.

Expressionistin or 'Modern Primitive'

Whereas it was mainly in the last thirty years of the twentieth century that
feminist intervention substantially altered the course of cross-disciplinary
scholarship, the answers to the question as to why women artists disappeared
from the text after 1933, only to reappear at the end of the twentieth century,
are complex.[5] They encompass the fields of history, sexual and cultural politics,
and the historiography of modern art history. Certainly, a major factor for
the occlusion of women artists from accounts of early German modernism
arises from the impact of the Third Reich between 1933 and 1945. At a time
when they could have been enjoying the conjunction of their emancipation
(achieved in 1919) with the benefits of a pluralistic art market, women
modernists' careers were blighted.[6]

 Never as favourably courted as their male colleagues in the institutional
endorsement of modernism during the 1920s, women Expressionists none-
theless had their works associated with 'degenerate art' and confiscated in
the Nazi purge of public collections.[7] In the case of Münter, the gradual
invasiveness of Nazi official culture and reduction of outlets for the display
of modern art led her (short-sightedly) to contribute two paintings, arising

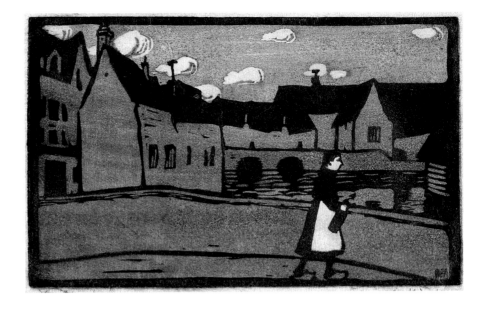

Fig. 22 Gabriele Münter,
Bridge in Chartres (Brücke in Chartres), 1907
Colour linocut, 9.6 × 14.9 cm
Städtische Galerie im
Lenbachhaus, Munich

from numerous sketches made of the urban development at Olympiastraße near Garmisch, to the travelling exhibition '*Die Straßen Adolf Hitlers in der Kunst*' (The Streets of Adolf Hitler in Art) in 1936.[8] The following year, however, when she exhibited at the Münchner Kunstverein (Munich Art Association), the Nazi Bavarian Minister of Education and Culture Adolf Wagner castigated her works and as a consequence of this branding Münter's isolation intensified. In general, even if they managed to survive in exile or retreated into 'inner immigration' in Germany, few women artists were recuperated in the immediate post-war period. Münter, in fact, fared better than most given that she managed to protect her oeuvre and an extensive collection of Kandinsky's works from the threat of Nazi confiscation and Allied bombing.[9] Stored in the basement of her house in Murnau, this collection when discovered astounded Munich-based art historians and museum directors, who recognized Münter's importance as one of the few surviving members of the *Blaue Reiter*. However, such acknowledgement was the exception rather than the rule: the tragic circumstances of the Rhenish Expressionist Olga Oppenheimer (1886–1941), whose precarious mental health and Jewish identity led to her deportation and murder in Poland, resulted in the loss of her oeuvre, with only a few paintings remaining in the hands of family members.[10] On a methodological level, while one has to be wary of interpreting the historical trajectory from Second Empire to Holocaust as 'inevitable',[11] its legacies are ever present in tracing the cultural production of the early twentieth century.

Since the 1950s, art historians have been selective in adopting the paradigm of male artistic genius as their measure in order to define the term 'Expressionism'. This they could find in the first documentary history of the movement *Der Expressionismus*, published in 1914, in which the art critic and newspaper feuilletonist Paul Fechter established parentage for the movement

in the Norwegian artist Edvard Munch and progeny in the works of the *Brücke* artists, the male protagonists of the *Blaue Reiter* and individuals such as Oskar Kokoschka and Ernst Barlach.[12] The overarching narrative has not changed substantially, with the exception perhaps of new evidence and emphasis on other regional manifestations of the movement and the recognition of a later, second generation of Expressionists, who participated in the revolutionary fervour of the early Weimar Republic.[13] Although recent trends in the secondary literature have devoted attention to the broader issues of art, society and cultural politics, their focus almost invariably dwells on the contribution of male protagonists, whether artists, sculptors, writers, supporters or promoters of the movement. When the names of women are mentioned, their roles are marginalised to that of student, muse, lover or wife, notwithstanding evidence that the notion of the *Expressionistin* (woman Expressionist) was present in critical and theoretical discourses.

Indeed, in 1914, in the same year as Fechter's publication, when reviewing a posthumous exhibition of the work of Paula Modersohn-Becker (1876–1907), the critic Anton Lindner wrote:

> Paula Modersohn is thus a woman Expressionist [*Expressionistin*]. She is the earliest Expressionist of modern painting in the German field. She was the fearless and unflinching forerunner of a creative style that today (seven years after her death and about ten years after the genesis of her strongest works) commands the widest range of the visual arts. Therefore, one must characterise her as a remarkable phenomenon (not only from an art philosophical but also from a sexual, scientific viewpoint).[14]

Lindner's commentary links Modersohn-Becker to Expressionism as it had come to be known on the eve of the First World War, well after her death, and he puts her at the centre of that ongoing revolution in artistic practice and painterly style. In addition to acceding to her geniality, we are informed that this phenomenon held implications (both sexual and scientific) for the body of the woman artist.[15] Whereas in general societal constructions of the terms 'woman' and 'artist' were mutually exclusive, in this instance the engendering of the artist was considered a virtue. Yet Lindner also held another agenda for categorizing Modersohn-Becker as an *Expressionistin*; he pointed to the importance of her cosmopolitan experiences in Paris as being essential to counteract provincialism and attested to these by quoting extensively from her letters and journals, abridged versions of which were published in 1913.[16] Hence, a major woman painter's works and writing were accorded their

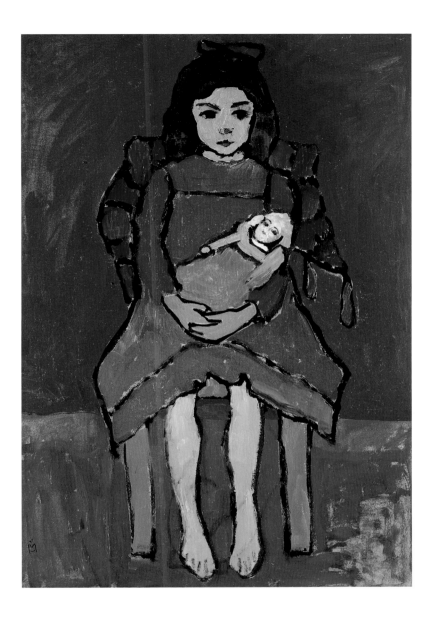

Fig. 23 Gabriele Münter, *Young Girl with Doll (Mädchen mit Puppe)*, 1908–09
Oil on canvas, 70 × 48.8 cm
Milwaukee Art Museum, Gift of Mrs Harry Lynde Bradley

inscription in contingent debates regarding the 'modern' and the 'foreign', escaping the chauvinism that was rife among German intellectuals at the time.[17] Lindner's use of the feminine ending (*Expressionistin*) seemed at that point, and still does, a new coinage that serves to put the issue of gender dynamics at the core of the movement.

Interestingly, in a subsequent survey of 1916, the writer, art and literary critic Hermann Bahr was less dogmatic about the gender of the artist and, in a compelling fantasy, he cited an anonymous young woman as the exemplary Expressionist. He located her not in the fashionable city but firmly in German territory, in the untainted Eastern provinces. On entering her studio it was as though he was suddenly in the centre of Paris, the young lady painting after Matisse and Picasso. Though unworldly and untrained (she painted purely for

pleasure), she knew of the new painting merely from art magazines. Impelled by the modern artistic will (*Kunstwollen*), she could do no other than follow these instincts: 'She paints as she had to paint, she could do no other.'[18]

Bahr was familiar with art historical methodologies which argued that changes in style were not the result of lack of skill (*Können*) but were propelled by a psychic relationship – whether secure or insecure – with the external world.[19] He was also one of the few commentators to refer explicitly to *Weltanschauung* as being determined by different modes of perception. Here he distinguished between the *Auge des Leibes*, the eye of the body, that was characteristic of the Impressionist, and the *Auge des Geistes*, the eye of the spirit or the soul, that had been inherent in the earliest art (*Ur-kunst*) and now in Expressionism.[20] The art of self-expression, or *Ausdruckskunst*, as it was articulated in German, involved a degree of expressive intensification and distortion that differed from the mimetic impulse of naturalism and the Impressionist mode of capturing the fleeting nuances of the external world. From Bahr's allegory outlined above, the woman painter emerges as the paradigmatic 'modern primitive', who was able to access those primal sources of creativity in the face of modernity. He was writing at a time when Germany had suffered staggering reversals on the battlefield and disillusion-ment had set in with gas and mechanized warfare of a kind that no one had imagined earlier.[21] Fiercely anti-technological and anti-bourgeois, Bahr characterized the era as a 'battle of the soul with the machine', articulating the desire for a pre-lapsarian state of innocence.[22]

This interpolation of 'woman' as the bearer of culture has its parallel in the annals of the bourgeois feminist movement. Apart from harbouring conservative referents of national regeneration during the war, maternalism was presented as the fostering of women's culture (*Frauenkultur*), which was considered capable of counteracting the negative effects of masculine science and industrial technology.[23] Wittingly (since Bahr was supportive of feminist causes)[24] or unwittingly in the context of the First World War, Expressionist intuitionist theory endorsed these tenets and provided the co-ordinates for the feminisation of the movement. This reconfiguration of Expressionism highlights that its theorisation was more complex than is traditionally suggested and, furthermore, offers a nuanced explanation of why so many critics reacted against it in the post-war period. By 1919, they came to view Expressionism as decorative, ornamental and depleted of its potential for social change. The art historian and critic Wilhelm Hausenstein decried both the presence of 'numerous dilettantes who want to be expressive at all costs while expressing

nothing' and the ubiquity of Expressionism in advertising and the commercial world.[25] In drawing metaphorically on gendered distinctions between high and low art, Hausenstein articulated fears of the threat of 'mass culture as woman' and Expressionism's debasement in esoteric formalism.[26]

How does this excursion into the concepts of the *Expressionistin* and Bahr's ideological feminisation of Expressionism assist in considering Gabriele Münter's role in early modernism? As in the case of Modersohn-Becker, we would be comfortable in according her the attributes of an *Expressionistin* – a woman Expressionist who, at a time when there was great suspicion of the 'modern' and the 'foreign', was located at *the* nexus of cosmopolitan avant-gardism and the complex social transformations brought by modernity to pre-emancipation womanhood. However, notwithstanding her avid interest in Bavarian folk art and search to recover a medieval, German authenticity for her painting, we would hesitate before labelling Münter a 'modern primitive'. Since Expressionist theory emphasises the values of the 'untutored', the 'intuitive' and the 'spontaneous', it is difficult to extricate women's artistic agency from the metaphoric associations of their gender in cultural practice.

It has taken years for Münter to emerge from the shadow of Kandinsky who, eleven years her senior, was both her tutor and her lover between 1902 and 1916. Beyond his reputation as one of the founding fathers of abstraction, Kandinsky was a prolific writer and publicist, his well-known treatises such as *Über das Geistige in der Kunst* (On the Spiritual in Art, 1912) securing his place in the history of modernism. Whereas the overall impact of the large retro-spective exhibition of Münter's works in 1992–93 brought into question the role traditionally assigned to her as a mere companion or muse, her ban on the publication of her writings until fifty years after her death has prevented academic scrutiny of their theoretical implications.[27] Abridged versions of her correspondence and journals have been published but, on the whole, art historians have assumed that the apparent lack of written testimony is sufficient evidence for Münter's supposed simplicity of character and intuitive directions in art.[28]

Yet it is to her second partner, the art historian Johannes Eichner, that we owe the dubious elision between psychological character and artistic production, between Münter's so-called naïve temperament and '*echte Primitive*' (truly primitive) artistic statement, defined in opposition to Kandinsky's intellectual and spiritual contribution to the origins of modern art.[29] Münter herself contributed to this legend in conveying Kandinsky's observations on her talent to Eichner:

You are hopeless as a pupil – it's impossible to teach you anything. You can only do what has grown within you. You have everything [instinctively] by nature. What I can do for you is to protect and cultivate your talent so that nothing false creeps in.[30]

As a consequence of this perception of her work as aligned with nature, never capable of approaching male artists' sublimation of the 'primitive' into high art, scholarly appraisal of Münter's reinvention of the lesser genres – landscape, still life, portraiture, interiors – has been sorely neglected. These characteristics of her reception have to be assessed critically in relation to her creative processes (involving draughtsmanship, photography, graphic production and painting), the development of her oeuvre and her engagement in the avant-garde discourses of Expressionism.[31]

Alongside the compelling narrative of her life with Kandinsky, it is appropriate to consider how she retained a strongly figural art notwithstanding her mentor's programmatic dedication to abstraction. In order to dispel the myths that have remained the hallmarks of Münter's reception – a state of affairs that continued unabated into the 1970s[32] – this essay explores the valences in her portraiture, an area of specialisation that Kandinsky abandoned after 1905. It is important to detect the nuances of the symbolic associations functioning in her works that were so crucial to early German Expressionism – how they came to embrace aspects of the 'modern', the 'foreign', the 'primitive' as well as the 'regional'. Clearly, her position as a woman and artist involved varying and shifting constructions of agency. The notion of 'positionality' implies a complex physical and signifying relationship to structures of power, be they parental, societal, political or institutional.[33] Within a milieu that harboured conflicting social expectations of single upper middle-class women, Münter's training and career serve to illuminate women artists' uneasy negotiation of professional and cultural identity in late Imperial Germany.

New World and Apprenticeship

As was her habit at the start of each year, Münter inscribed the 'year's motto' in her pocket calendar. That she chose the dramatic aphorism – 'The harder the struggle: the greater the victory'[34] – at the turning point of a new century signals her acquaintance with the writings of the philosopher Friedrich

Nietzsche. His propagation of individualism and a romantic form of liberalism in his book *Also sprach Zarathustra* (Thus spoke Zarathustra, 1883–85) became integral to her efforts to strive towards future goals. Interestingly, this entry in her calendar coincided with Münter's and her sister Emmy's extended tour of the USA between 1898 and 1900, visiting relatives of their deceased parents. In many ways this was a pilgrimage for Münter, given that she cherished her mother's tales of her upbringing in Texas and early married life in Tennessee, before the couple returned to Germany in 1864. If Münter inherited a pioneering spirit from her mother in refusing to conform to the decorum of *haute bourgeoise* society, she also valued the stories of her father's radical idealism that had resulted in his political exile in America before the 1848 revolution in Germany.[35] Since he left a large inheritance to the children, which was administered by her brother Carl, Münter shared none of the pressures that compelled other so-called *höhere Töchter* (bourgeois young ladies) to find employment as governesses or teachers.[36]

In 1900, one of Münter's first drawings was of a *Girl with a Doll* (fig. 24), and many of her sketches in Plainview, Texas, seek out the rituals of play and leisure activities of landholders' children. Yet, as we have seen (fig. 23), the theme of childhood was of consistent relevance to Münter, her interest in the notion of youth responding to various intellectual and aesthetic imperatives at the turn of the century. For many artists Nietzsche offered a compelling metaphor of futurity in the child as a regenerative principle, the creative person being aligned both with the new-born child and the procreative act: 'For the creator himself [*sic*] to be the child new-born he must also be willing to be the mother and endure the mother's pain'.[37] This attempt to return to an innocent vision had its precedents in Romanticism but twentieth-century notions of childhood were predicated on a distinctive climate of social and cultural reform in which the spontaneous and uninhibited responses of children were greatly valued as a source of authentic and untainted culture. Prior to her American visit, Münter's brief training in Düsseldorf must have introduced her to the principles of *Jugendstil*, or 'youth style', a term that gained currency through circulation in the Munich-based periodicals *Jugend* and *Simplicissimus*. In rejecting mechanization and advising a return to handcraft and the organic, simplified rhythms of nature, the aspirations of *Jugendstil* were allied with those of the Applied Arts movement.

The homestead at Plainview, established a mere twelve years prior to their sojourn, offered Münter a unique model of a New World outpost with the prospect of expansion, given its location on a cattle trail. Her acquisition of

the most up-to-date model of a Kodak Eastman (No. 2) camera on her twenty-second birthday gave rise to a substantial portfolio of over 400 photographs, the trope of travel informing Münter's photography of the vast treeless plain surrounding the settlement where her Uncle Joe Donohoo advertised himself as a 'Dealer in Cattle' soliciting 'Contracts for Future Delivery'.[38] Here, as the cultural theorist W.J.T. Mitchell has observed of imperial landscape, 'Empire moves outward in space as a way of moving forward in time; the prospect that opens up is not just a spatial scene but a projected future of "development" and exploitation.'[39] Since it was only in 1907 that the Pecos & Northern Texas Railway reached the town, Münter's lessons in horse riding were put to good use in attending a 'Cowboy Reunion'.[40] However, her experiences of the Wild West were also mediated by popular literature, and a copy of Chas A. Siringo's *A Texas Cow Boy. Fifteen Years on the Hurricane of a Spanish Pony Deck (Taken from Real Life)* (1886) resides in the library of Münter's estate in Munich.[41]

In such a setting, the disparities between home and away, self and other, civilization and wilderness were magnified. The drawing *Girl with a Doll* reveals Münter's ability to capture likeness and the casual pose of the young girl, who slips her foot behind the leg of the chair in order to stabilise her body. With deft contours, Münter focuses on the salient details of the chair, profile head and child's clothing, distilling these components into a subtle flowing silhouette conforming to the dictates of *Jugendstil*. This simplicity of treatment contrasts with the dense shading and hatched strokes of the coiffure and dress of the doll. Such disjunctions function in an anagogic manner to invest the forms with symbolic associations beyond the literal, from the girl's presence as a 'child of nature' to the doll's animated sophistication. Although anti-academicism may have been a feature of Münter's mature work, these early drawings testify to her traditional graphic skills: five sets of remarkable drawings of heads in profile, in pencil, survive from her schooldays, and her six American sketchbooks include representations of adults, landscape and plants. As a repertoire, this material deserves more focused research the better to explore the transformation or disruption of motifs across the chronology of Münter's oeuvre.

In the period under consideration, from 1890 to 1919, historians have detected uncomfortable shifts in German identity, from the Enlightenment concept of Germany as *Kulturnation* to that of *Machtstaat* (Imperial state) and to subsequent loss of Empire. Geoff Eley suggests that neither liberal reform nor the abstract utopia of middle-class society could be protected against the contamination of imperialism.[42] Other commentators have made strong

claims for German colonialism as an emancipatory space for German women in their critique of Wilhelmine patriarchy.[43] The impact of Münter's travels and encounters in America can be debated in light of both premises; whereas her role as an explorer hints at imperialism, her quest to map the coordinates of her parents' recollected pasts and memories serves as an exercise in self-ethnology. Such discoveries empowered her, providing an understanding of her attachment to notions of *Kulturnation,* given that the political nostalgia for 1848 was enshrined in German-Texan folklore.[44] She consolidated her desire as well to become an artist, but, on her return to Germany, was sharply reminded of the lack of equal opportunity for professional training.

Although her preference would have been to enrol in an Academy of Art, women were denied access to such institutions before 1919.[45] From May 1901, while ensconced within the community of the 'Ladies' Academy' of the Münchner Künstlerinnen Verein (Munich Women Artists' Association), she developed her talents within a competitive environment availing herself of a social milieu in which women's rights were fiercely debated.[46] Surprisingly, it was only in 1908 that an imperial Law of Association permitted women's participation in political gatherings. Armed with her camera, Münter engaged in the mechanisation of visual culture through photography, a process that placed her firmly within the experiential realms of modernity. If we examine the photograph of her studio and living quarters in no. 4 Schackstraße, Munich, of around 1903–04 (fig. 25), it becomes clear that the image constitutes rather than reflects meaning.

Notwithstanding the fact that the artist is absent from the *mise en scène*, we can detect her constructed presence through the strategic placement of her

palette and brushes and the display of her paintings. Her routine of instruction at the Ladies' Academy, which focused on drawing from the partially clothed nude, character heads and landscape, had been replaced by her enrolment at the Phalanx school from January 1902. Along the piano, Münter has arranged her landscape painting, which she pursued *en plein air* on excursions to the Bavarian countryside under Kandinsky's tutelage. In addition, her identity as painter emerges in the figural works, resting on and at the base of the easel. Here we can observe her mastery of the nude female model, yet it is the boldness of the portrait heads, usually working-class women or peasants who posed for the students, that attracts our attention.[47] These unfinished studies reveal Münter's development of a painterly style without foregoing her subtle graphic ability to retain the individuality of her sitters. They also signal her future and unusual deployment of the body fragment and sketch as entities within themselves. Paradoxically, although the photograph of the interior asserts her professional commitment, Kandinsky's gouache *The Night (Walking Lady)* of 1903 is given pride of place above the bookshelf.[48] Since his painting depicts a fantasy of decorous medieval womanhood, it deflects from Münter's status by registering her complex emotional ties to her tutor.

While Kandinsky was teaching at the private Phalanx school between 1901 and 1904, the direction of his art was far from settled. His landscapes painted *in situ* retained local colour but focused on varying directional uses of the palette knife. This exploratory, rugged technique differed from the lyrical qualities of his early woodcuts, gouaches and designs for applied arts that were consistent with the aims of *Jugendstil*. Indeed, though disparaging the academic practice of drawing from the model as a 'constraint' upon his freedom in his *Reminiscences* of 1913,[49] Kandinsky submitted a rather traditional painting of a young female nude in the spring exhibition of the Berlin Secession in 1904.[50] Some idea of his mode of representation in this vein can be gauged from the *Portrait of Gabriele Münter* (fig. 26) which he painted in Dresden in 1905, when Münter joined him for a bicycle trip in Saxony. Although she posed for the portrait, Kandinsky also photographed her at the time and probably used the photograph as a reference.[51] It is a serious portrayal that, without flattery, invests the sitter with a down-to-earth candour, albeit contrary to the tenor of his correspondence at the time that addressed Münter in sacred terms – as his 'goddess' (*Göttin*), his 'source of life' (*Lebensquell*) and his 'heavenly messenger' (*himmlischen Boten*).[52] The allure of femininity and virtuoso brush-stroke is limited to the transparency of the blouse and loosely tied sash, the facture in the face appearing somewhat inhibited in comparison. Rather than

Fig. 26 Wassily Kandinsky,
Portrait of Gabriele Münter
(Bildnis Gabriele Münter),
1905
Oil on canvas, 45 × 45 cm
Städtische Galerie im
Lenbachhaus, Munich

looking forward, the portrait harks back to his training in the studio of Anton Azbè and the Academy classes of Franz von Stuck who, broadly speaking, propounded a Germanic hybrid of 'naturalistic Symbolism'.[53] Not surprisingly, Kandinsky thereafter distanced himself from portraiture in pursuing experimental small-scale landscapes and figural scenes of Old Russia.

Although Kandinsky had separated from his wife Anja Semjakina, social convention dictated that he and Münter maintain decorum in Munich, reserving their cohabitation for extended visits abroad. This peripatetic mode of existence, which continued until 1908, was dictated by personal reasons. However, travel had a significant effect on their art, Münter in particular seeking out cosmopolitan experience and the opportunity to explore modern artistic identity. In November 1906, during a period of estrangement from Kandinsky, who remained in Sèvres, she rented a room in no. 58 rue Madame, the house in which Michael Stein – the brother of the famous writer and collector Gertrude Stein – lived with his wife Sarah. Münter may have had access to their large collection of Fauve paintings but in any case she was actively engaged in pursuing motifs of urban modernity and in attending exhibitions. Intriguingly, alongside a study for a graphic *In the Café 1* (fig. 27) in her sketchbook, she listed the names of major artists and a gallery: 'P. Gauguin, van Gogh, Monticelli, Odilon Redon, Cézanne, Matisse, M. Denis, Berthe Morisot, Degas, Signac, Renoir. Rue Bellechasse 51. Galerie Fayet'.[54] She attended classes twice a week at the Académie Grande Chaumière and had the occasion to be taught drawing by the well-known graphic artist Théophile Steinlen.[55]

Yet it is precisely in the dialogue between the metropolis and the private studio that we can measure her progress for, by mid 1907, apart from her paintings, she had produced ten sketchbooks of over 450 pages and twenty-five graphics, eight of which were portraits cut from linoleum sheets, an

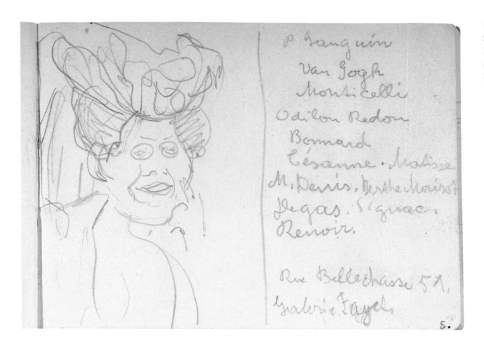

Fig. 27 Gabriele Münter,
Sketchbook study for the
linocut *In the Café 1*, 1907, with
a list of artists and a gallery
Städtische Galerie im
Lenbachhaus, Munich

Fig. 28 Gabriele Münter,
Kandinsky, 1906
Colour linocut, 24.4 × 17.7 cm
Städtische Galerie im
Lenbachhaus, Munich

industrial material that had been invented in England in the mid-nineteenth century.[56] Used as a surrogate for wood, marble or carpets, linoleum also displaced traditional woodblocks in avant-garde experimentation, Münter's portrait of *Kandinsky* (fig. 28) being the first result of her exploration of this medium in Paris. As in the other portraits, Münter set the crisp bold silhouette against a background that identified the sitter with a sphere of his/her activity. In this case, she used simplified, organic shapes – possibly of landscape origin – delineated by contour, a synthesising mode much discussed in contemporary artistic circles. A major retrospective exhibition of Gauguin's works, including the woodcuts from the artist's book *Noa Noa*, attracted great attention at the Salon d'Automne of 1906. As a riposte to Kandinsky's *Portrait of Gabriele Münter*, she achieved an expressive characterization of masculine artistic interiority through the significance accorded to abstracted shapes, colour and sinuous line.

This linocut was exhibited in 1907 along with four other portraits at the Salon d'Automne, Münter submitting seven further examples to the same venue in 1908. Her contribution to the latter exhibition was incisively reviewed in the Symbolist magazine *Les Tendances Nouvelles*, which also reproduced her graphics in 1909:

> It is remarkable how fast Mlle Münter has managed to win a really enviable place. She displays in her prints – unmistakable in their way of seeing things – a feminine sensitivity mixed with a very individual severity.[57]

It is possible that the reviewer seized on the disjunctions between Münter's modernising, 'feminine' aesthetic that was Paris-inspired and her inimitable adaptation of *Jugendstil* clarity. However, such a conclusion would be reductive. On occasions, Münter's portraits border on caricature and on an

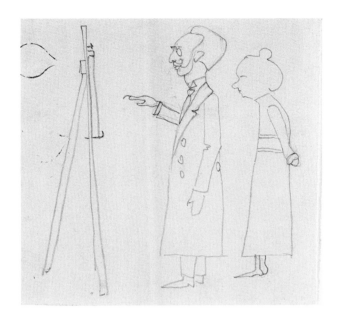

Fig. 29 *Caricature: Münter and Kandinsky in front of the Easel (Karikatur: Münter und Kandinsky vor der Staffelei,* Tunis, 7 March 1905 Pencil, 8.7 × 8.6 cm Städtische Galerie im Lenbachhaus, Munich

exaggeration of physiognomic peculiarities that suggest a more subversive scrutiny of the subject. At its extreme, we can find this in a caricature, *Münter and Kandinsky in front of the Easel* (fig. 29), which dates from their visit to Tunisia, where the relationship between tutor and woman student was evidently under strain. The drawing is unsigned and undated but is inscribed on the verso by Münter with the place and date (Tunis, 7 March 1905). It may have been a collaborative work – one or the other feasibly adding the curved extensions to Kandinsky's thumb, forefinger and moustache in a playful manner – but its distilled style of drawing is closest to Münter's hand.[58] Here she is portrayed as a dim-witted and downtrodden *Malweib*, a derogatory term for a female painter, whose visibility in studio and public life appeared to threaten the hegemony of male artistic practice.[59] Kandinsky, on the contrary, is depicted as arrogant and self-centred. In the art journal *Simplicissimus*, which specialized in social and political satire, the artist couple may have encountered a caricature by Bruno Paul depicting the *Malweib* as unattractive, lanky and lacking femininity. Watching over the shoulder of the male artist, who is demonstrating how to paint, the woman is informed: 'You see, miss, there are two sorts of women painters: there are some who want to marry and the others also have no talent'.[60] However, in the caricature *Münter and Kandinsky in front of the Easel*, the focus on the profile portrait is decisive, evoking Johann Caspar Lavater's studies in physiognomy in the late eighteenth century, in which this configuration was favoured since it 'offered the head for objective study, undisturbed by the mobility of features expressive of social interaction'.[61]

Although the precise authorship of this caricature is in question, the fact that it was part of their discourse is sufficient testimony to its relevance. That Münter would have had recourse to such theories as Lavater's can be ascertained from her library, where a copy of O.S. Fowler's *The Illustrated*

Self-Instructor in Phrenology and Physiology with one hundred Engravings and the Chart of Character (1857) can be found.[62] It was presented to her father Carl Friedrich Münter in America in the year of its publication and, with due diligence, he proceeded to measure the circumference of his head and to check that the opening of his ear 'should not be more than 2 eighths of an inch below the eye' when completing the chart! Whereas Münter claimed in her reminiscences that her inclination to draw received more encouragement in her schooling than from her parents, they nonetheless bequeathed her traces of their eccentric intellectual formation.[63] In so far as a satirical edge played an important role in Münter's depiction of the personalities she encountered in the avant-garde circles of the NKVM and *Blaue Reiter* in Munich, it is important to acknowledge that, at times, the abstracting processes underlying her portraiture were informed by a complex web of signification.

Kandinsky's directives were still apparent in her work until her return to Germany in mid 1907, as in the fascinating study for *Bridge in Chartres* of 1907 (fig. 21, p. 44), where his handwriting in pencil enumerates the areas of shadow and light ('*Schatten und Licht*') in guiding Münter's preparations for the coloured linocut. Nonetheless, she had found a place in the Paris art world and thereafter strove to secure a niche in the competitive market economy of late imperial Germany.[64] In 1908, reviews of her solo exhibition at the Kunstsalon Lenoble in Cologne, which included eighty paintings – landscape studies from Rapallo and the Paris period – found her 'luminous Impressions' insolent but valued the 'special boldness and an unusual striving seriousness' in her pictures.[65] Kunstsalon Lenoble thereafter devoted an exhibition exclusively to her print production, which travelled to Friedrich Cohen's bookstore in Bonn. She certainly had transcended her role as apprentice.

Differencing 'synthesis'

With Münter's acquisition of her house in Murnau in 1909, Kandinsky's securing of a divorce and purchase of a more permanent abode in Munich in 1911, the period before World War I appeared more settled for the couple. In their alternation between Munich and Murnau, their artistic partnership inevitably dwelt on city/country themes and was framed by their launch of the NKVM, an exhibiting society formed in 1909, and the *Blaue Reiter* group, established in late 1911. Kandinsky, Münter, the expatriate Russian woman artist Marianne Werefkin and her companion Alexej Jawlensky were among

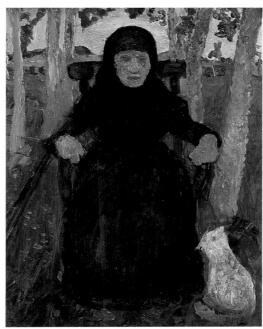

Fig. 30 Gabriele Münter, *Murnau Woman (Murnauerin) (Frau Schönach)*, 1909
Oil on board
Private collection

Fig. 31 Paula Modersohn-Becker, *Seated Old Woman with Cat (Sitzende Alte mit Katze)*, 1904
Oil on board mounted on canvas, 72.6 × 56 cm
Kunsthalle in Emden, Stiftung Henir und Eske Nannen

the key members of this Association, which was founded at Werefkin's residence in Schwabing, the artists' and intellectuals' quarter of Munich. Membership of the group was open to women practitioners and international, drawn from the performing, literary and visual arts, testifying to the make-up of the social milieu.[66]

When she resumed portraiture, Münter's first sitters were models who were readily available, the children of Murnau residents (fig. 23) and local inhabitants. No doubt Münter was aware of the Dachau artists' colony, a mere 17 kilometres north of Munich, where the Secessionists Ludwig Dill and Arthur Langhammer set their compositions of idealised peasant life in the moisture-laden moors. However, in her portrait of a *Murnau Woman (Frau Schönach)* of 1909 (fig. 30), the figure partakes of the viewer's space and is brought close to the picture plane. This feature, the interest in regional costume and the denser facture of the gnarled face and hands, in contrast to summary washes of paint, are comparable to Modersohn-Becker's portrayal of elderly peasant women, as in *Seated Old Woman with Cat* 1904 (fig. 31). Painted in the Worpswede artist's colony, north of Bremen, this theme was explored in several variations, Modersohn-Becker on this occasion opening up the background to reveal the horizon and placing the dark silhouette of the figure in front of an avenue of birch trees. Hence the portrait is set emblematically against the constructed typicality of the region, signalling that the artist was cognisant of a receptive audience already initiated in a forceful mythology of the region as untainted by modernisation.[67] Münter, however, places the *Murnau Woman* against a neutral ground, the stylisation of the features and paint application resonating with the ongoing vogue in Germany for the works of Van Gogh.[68]

Fig. 32 Murnau farmer's wife
(Frau Schönach) in front of
her house, Murnau (*Murnauer
Bäuerin (Frau Schönach) vor
ihrem Haus, Murnau*), 1909
Photograph by Gabriele
Münter
Gabriele Münter - und Johannes
Eichner-Stiftung, Munich

Yet this motif was extracted from the broader format of one of Münter's photographs in Murnau (fig. 32).[69] In addition to the 'characteristic type' of native inhabitant, the photographic composition includes a 'scenic' architectural setting and a figure shown lurking in a doorway that allude to images – *Scènes et Types* – promoted in contemporary travelogues and commercial photography in the colonial era. When compared to the photograph it is evident that the portrait of the *Murnau Woman* involves a variation of the viewing point, indicating that Münter probably used the photograph interchangeably with *in situ* sketches as points of departure. Whereas these different creative processes partake of the discourses of travel and the expanding tourist economy of the region,[70] the painting disrupts the power dynamics of the colonial as well as the male gaze owing to the viewer's closeness to the subject, its technical radicalism and Münter's individualisation of Frau Schönach's facial features. Here we see how the woman artist's misinformed quest for *Natur* (rural piety and authenticity) was implicated by modernity and how the portrait simultaneously bears levels of association with the 'modern', the 'foreign' and the 'regional'.

Although the existence of innumerable sketchbooks from all periods testifies to the artist's systematic reliance on preliminary studies for her final paintings, it is evident that Münter painted very quickly, often completing one or more large-format pictures in a single afternoon.[71] Her *Portrait of Marianne Werefkin* 1909 (fig. 33) would appear to be one of those completed

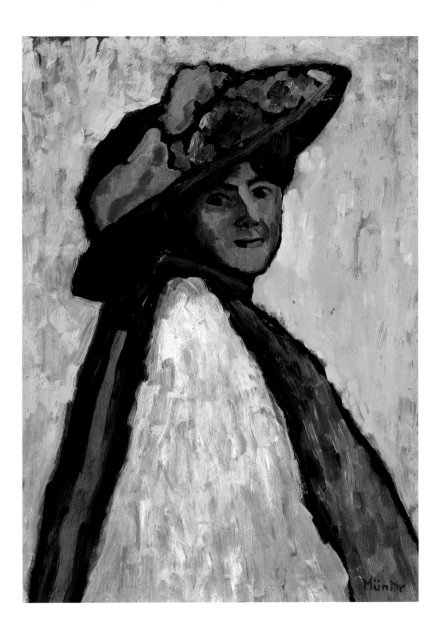

in a single sitting. Painted in Murnau, this work lies at the other end of the spectrum to the previous portrait in negotiating the spectacle of an urbane woman's sojourn in the Bavarian town. In an undated note, Münter recalled:

> I painted the Werefkina in 1909 before the yellow base of my house. It was a bombastic appearance, self-confidently, authoritatively, richly dressed, with a hat like a carriage wheel, on which all kinds of things had a place.[72]

Münter had previously painted a double portrait of Werefkin and Jawlensky in a Murnau landscape (cat. 9) in which her associate was portrayed wearing the same impressive wide-brimmed sun hat. Since Werefkin was forty-nine years old at the time, the image that Münter conveys presents certain

anomalies.[73] She idealises the older woman, the casually elegant draping of the long scarf and tipped hat reinforcing a youthful demeanour. Demonstrating her technical command and fluency with codes of expressive emphasis that are as audacious as Fauvist painting, Münter arranges the three-quarter-length figure against a freely painted yellow ground (the wall of her house). The triangular composition and directional brushstroke guide our attention to the head, which is turned towards the spectator but glances sideways. Discordant colour combinations, the largely olive tones of the face reflecting the plum-like colours of the scarf, reinforce this focus. Thickened dark lines furthermore circumscribe colour areas, making them function as vibrant shapes.

In reviewing the first exhibition of the NKVM, the art critic of the *Rheinisch-Westfälische Zeitung* appeared to lack the experience and vocabulary to assess the abstraction in Münter's portraiture:

> Gabriele Münter literally imitates the drawings of small children, of which the most modern education has made too much fuss – this uninhibited manner that flies in the face of any sense for perspective and natural forms and that makes out hideous features to be human faces, green spots to be eyes, square blocks to be noses, broad slits to be mouths, must be rejected. The broad mass of spectators must be protected from such a sight; will they not otherwise also become mad? – The principle 'sensation at any price' does not belong in an art exhibition.[74]

Whereas the critic is perceptive in detecting the importance of child art to Münter, one is curious as to why he felt that these works were so troubling – her submission included two portraits of women - and why spectators required protection.[75]

While Münter's Paris sojourn had acquainted her with Synthetist aesthetic theory, particularly in relation to her coloured linocut portraits, the epochal Murnau visit of 1908, in which she, Kandinsky, Werefkin and Jawlensky forged their relationship and pursued shared interests, initiated a period of interaction that involved their testing of the limits of painting within the landscape genre, as well as activating their interest in folk art. In her diary Münter testified to her departure from an Impressionist mode of depicting nature, 'to feeling the content of things – abstracting – conveying an extract'.[76] She referred chiefly to Jawlensky, who 'passed on what he had experienced and learned – talked about "synthesis"'. Of the four artists, Jawlensky had the most consistent experience of the French avant garde and he adopted the

term 'synthesis' to apply to the technique of *cloisonnisme*, the radical simplification of form and colour, bound by line, so as to avoid anecdotal content.[77] Thereafter the term became a rhetorical catchword in Kandinsky's formulation of the programme for the catalogue of the first exhibition of the NKVM in 1909, where he proclaimed: 'We seek artistic forms ... that must be freed from everything incidental, in order powerfully to pronounce only that which is necessary – in short, artistic synthesis'.[78]

In her portrayal of women from her social and artistic environment, Münter certainly went beyond the incidental embodiment of the subject. As we have seen in her *Portrait of Werefkin*, this was not a prescriptive idealisation of form since Münter relied on a daring use of the phenomenological and sensate experience of space. Given that traditional artistic vocabulary was inadequate to signify women's entry into modernity, Münter's portraits suggest a 'new synthesis' where the abstracting processes – low viewing point, proximity, facture – direct the spectator to an unexpected assertion of womanhood. The anonymous reviewer cited above was certainly threatened by this 'show of force', these portraits functioning as an 'emblematic sign of the failure of power's symbolic currency'.[79] Since 'woman as a sign' is critical to this theorisation of 'synthesis', it differentiates Münter's practice from her male colleagues' usage of the term.

That her portraiture can be considered as part of a broader engagement with feminist discourses is confirmed in her correspondence with Kandinsky, where she reported in 1910:

> Wanted to read in the afternoon – the philosophy of the feminist Lessing – a new book *Weib, Frau, Dame* but the phonograph was going across the street ... – so I did some ironing – I always have my things quite tidy.[80]

Does this extract reveal the tensions between her feminist idealism and the confines of the domestic environment? The editor of their correspondence, Annegret Hoberg, would suggest otherwise, cautioning us that Münter's epistolary style, which includes an account of frequent changes of mood and almost trivial observations, arose from the couple's agreement to provide each other with a daily 'report' of their activities during absences.[81]

The arguments found in Theodor Lessing's tract *Weib, Frau, Dame* (Female, Woman, Lady, 1910) must have intrigued Münter. Before his departure for Hanover in 1907, Lessing was active in the resurgent liberal culture in Munich, where reformists addressed the so-called 'woman question'. As a

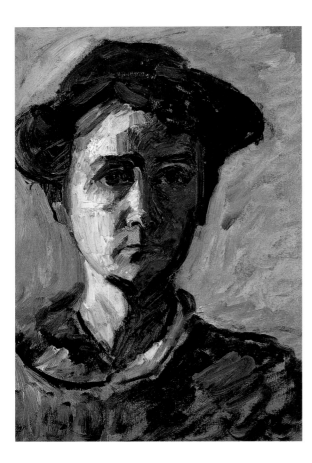

Fig. 34 Gabriele Münter,
Self-portrait (Selbstbildnis),
c. 1910
Oil on board, 49 × 33.7 cm
Fondazione Thyssen-
Bornemisza, Madrid

cultural critic, feminist and philosopher, he researched the etymological origins of the terminology applied to women. In so far as these historically laden terms conditioned psychology, Lessing suggested, language should find an alternative – a 'new synthesis' that embraced the values female/nature, woman/economy, lady/culture.[82] The concept of the *Überfrau*, the totally socialised and differentiated worker participating equally in the money economy, was considered to be crucial to women's advancement in the modern world.

It is instructive that Münter explored her self-image at this crucial time in her career, between 1908 and 1912, and in her *Self-portrait* of *c.* 1910 (fig. 34) reinvented the format of the 'character heads' that she had pursued during her training at the Ladies' Academy and Phalanx school.[83] It is painted directly on strawboard with large short-haired brushes, Münter dispensing with preliminary drawing. By contrast to her previous self-portraits, she also foregoes wearing fashionable clothing and dramatic hats for the occasion, the disequilibrium of the painter's smock and slightly dishevelled appearance being subservient to the impact of the exploratory and gestural brushwork. Throwing one side of the face into deep and yet coloured shadow, Münter achieved a range of Expressionist handling unprecedented in the works painted before World War I. Although the brushes and palette are missing, we are made keenly aware that the artist's subjectivity, a constantly shifting relationship within

social givens, was momentarily at one with her identity as a painter/worker, as *Überfrau*.

Of the larger, monumental works, which juxtaposed personalities from the circles of the NKVM and *Blaue Reiter* group with animated still-life objects in domestic interiors, *Man in Chair (Paul Klee)* of 1913 (fig. 35) provides an opportunity to explore how Münter represented her male colleagues. Paul Klee is portrayed wedged into an armchair that is set against an emerald-green rear wall of the Kandinsky and Münter apartment in Ainmillerstraße 36, Schwabing. While his legs in white shimmering trousers are depicted folded sideways, the upper torso in a stiff black jacket is displayed frontally and comically. The rectangular head, informed by Münter's combined fascination for physiognomic peculiarity and child art, competes with the dramatic arrangements of Bavarian *Hinterglasbilder* and votive figurines that vie for our attention. If we compare this with Münter's photograph of the interior (fig. 36), it is clear that she added further folk-art carvings to the array in the painting, confirming that she was active in enhancing the display of her personal collection. Rather than allowing the interior to be reflective of the male artist as a model of aesthetic sensitivity, Münter questions and subverts masculine control of domestic and private spaces.[84] This she does by compressing the figure spatially and by emulating the 'primitivist' techniques of folk art. Interestingly, as we have seen, the women in her circle were interpreted far more sympathetically.

So much is particularly evident during the Scandinavian period, Münter's move to Stockholm in 1915 being prompted by the hope of reconciliation with Kandinsky in a neutral country. In early 1916, this was achieved briefly when separate exhibitions of their works were arranged at Carl Gummeson's gallery in Stockholm. However, their separation became permanent when Kandinsky married Nina Andrejewska in 1917 in Moscow. Münter's series of women in interiors, focusing on the themes of isolation, illness or thoughtful reflection, which she produced in Stockholm during 1917, are among the most successfully mature and powerful of her oeuvre. By contrast to the mystical and primitive undertones of her Munich and Murnau interiors, these Swedish portraits focus attention on the contemplative mood, severe hairstyles and reform dress of early twentieth-century emancipated womanhood. The *Portrait of Anna Roslund* 1917 (fig. 37) shares similar attributes, and a subtle quality of reverie, but the forceful physical presence and specific identity of the sitter indicate an added dimension to Münter's professional activities in Scandinavia.

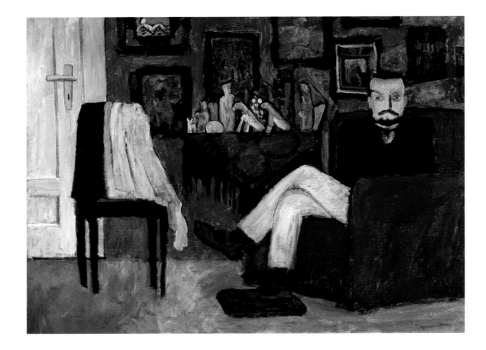

Fig. 35 Gabriele Münter,
Man in Chair (Paul Klee) (*Mann im Sessel (Paul Klee)*), 1913
Oil on canvas, 95 × 125.5 cm
Bayerische Staatsgemälde-
sammlungen, Pinakothek
der Moderne, Munich

The *Portrait of Anna Roslund* was painted in Copenhagen, Münter's move to Denmark feasibly being stimulated by the need to find a more lucrative base. The artist also subsisted by offering tuition in her 'Modern Painting School' and by accepting commissions for portraits, charging the amount of two-hundred *kroner* for two to four sittings. The *Portrait of Anna Roslund* could have been one of the earliest undertaken in Copenhagen.[85] An author and poet, Roslund published a book, *Den Fattiges Glädje* (Poor Gladness, 1915), that remained in Münter's library. Maintaining the economic linearity of her drawing technique, Münter defined broadly painted areas, subtly contrasting the jagged angularity of the clothing with the sinuous curves of Roslund's attenuated neck and limbs. In its severe range of colours and use of line, the portrait reveals the impact on Münter of the Swedish Expressionists, especially the woman artist Sigrid Hjertén, with whom she established contact in 1915. Characteristic of her coloration during this period, the scheme is reduced to tones of black, white, red and blue. Used for emphasis, the ice-blue eyes and simplified large red brooch function as dramatic highlights against the textured brushstrokes of the background and wicker chair. Importantly,

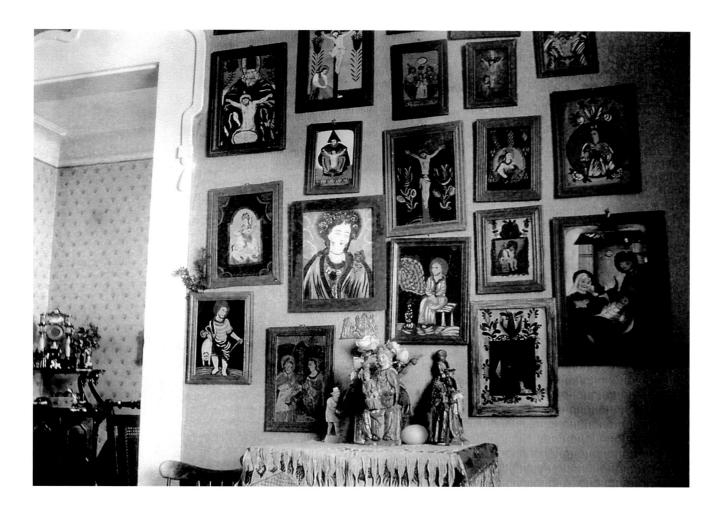

Fig. 36 *Hinterglasbilder*
wall in the Kandinsky and
Münter residence, no. 36
Ainmillerstraße, Munich, c. 1913
Photograph by Gabriele Münter
Gabriele Münter- und Johannes
Eichner-Stiftung, Munich

as in the preparatory sketches, the painting documents the fashion for women in bohemian circles to adopt the assertive masculinity of pipe smoking as a sign of independence from convention.[86] This authorises the image of the 'new woman' with the ability for creative fantasy.

The bravura displayed in this work totally belies the biographical events of Münter's life at the time and alerts one to the dangers of conflating the two. Ironically, it was precisely during this period of independence that she found it necessary to adopt the double name 'Münter-Kandinsky'. The *Portrait of Anna Roslund* was displayed in a major exhibition of Münter's works at *Den Frie Udstilling*, which took place in March 1918 at the Copenhagen Konsthall. Included in this event were a hundred of her oil paintings, twenty *Hinterglasbilder*, intaglio graphics and woodcuts. Fortunately, the private trauma caused by the termination of her relationship with Kandinsky neither effected Münter's prolific production nor her participation in the art world.

Against a backdrop of evolving Expressionist theory in the early twentieth century, this essay set out to address the gendered discourses of the movement. The three discrete sections sought to pose pertinent questions regarding the historiography of Expressionism, to reveal new scholarship and to locate

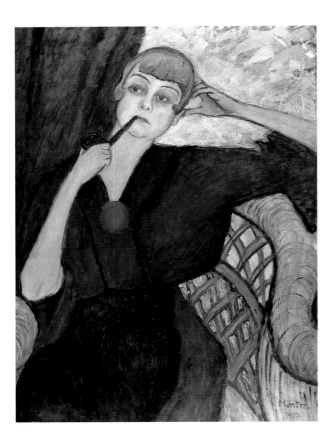

Fig. 37 Gabriele Münter,
*Portrait of Anna Roslund
(Bildnis Anna Roslund)
(Aagaard)*, 1917
Oil on canvas, 94 × 68 cm
Leicestershire Museum and
Art Gallery

Münter's development in historical time, as well as to stimulate further research. Focusing on previously ignored evidence in the critical discourses and documentary texts, the section entitled '*Expressionistin* or "modern primitive"' suggested a narrative of the movement different from those found in art historical accounts of Expressionism. The notion of *différance*, as espoused by the cultural philosopher Jacques Derrida, well characterises the movement of signification that welds together the difference and deferral, 'presence–absence', that typified women practitioners' relationship to early modernism.[87] Münter's 'pre-history' before Kandinsky yielded fascinating insights into the formation of her cultural and national identity. Her engagement in the experiential realms of modernity via photography, travel and sustained interest in feminist ideas was accompanied by a profound commitment to her professional role as artist. Frequently neglected, her acquaintance with the French avant-garde milieu served her as a valuable precedent for her forthcoming interaction with artistic communities in Munich and thereafter in Scandinavia. Münter as *Expressionistin* suitably locates her at the nexus of cosmopolitan avant-gardism as well as preserving her artistic agency from the vagaries of contemporary and historical criticism.

Notes

1 H. Eßwein, 'Ausstellungsrezension', *Münchner Post*, 10 December 1909: '*Ersten Ranges, ganz allerliebste naïve Märchendichtungen voll echten lyrischen Zaubers sind auch ein paar kleine Farbenholzschnitte von Gabriele Münter (Park, Häuschen, Alte, Brücke). Es ist einfach nicht zu fassen, wie jemand, dem solchen Kabinettstückchen gelingen, dann wieder in der Art dieser selben Gabriele Münter mit närrischen Farben und wüsten Linien auf der Leinwand herumzufuhrwerken vermag!*'

2 For further commentary on this category consult Cristina Maria Ashjian, 'Representing "Scènes et Types": Wassily Kandinsky in Tunisia 1904–1905', unpublished PhD, Northwestern University, Illinois, 2001.

3 Wassily Kandinsky, 'Pis´mo iz Miunkhena' [Letters from Munich], *Apollon* (St Petersburg), 1909, translated in *Wassily Kandinsky: Complete Writings on Art*, Kenneth Lindsay and Peter Vergo (ed.), Faber, London, 1982, p. 60.

4 See Alessandra Comini, 'Gender or Genius? The Women Artists of German Expressionism', in Norma Broude and Mary D. Garrard (ed.), *Feminism and Art History. Questioning the Litany*, New York, 1982, p. 289.

5 Here one must cite the critical role of German feminist art historians' enquiry into notions of 'gender difference', as initiated in the catalogue accompanying the exhibition *Künstlerinnen International 1877–1977*, Schloß Charlottenberg, Berlin, 1977, and in the various publications arising from the conferences of the group of Women Art Historians. The first publication was Cordula Bischoff and Brigitte Dinger *et al.* (ed.), *FrauenKunstGeschichte. Zur Korrektur des herrschenden Blicks*, Gießen, 1984. Also see Alessandra Comini's pivotal essay, 'State of the field, 1980: The woman artists of German Expressionism', *Arts Magazine*, vol. 55, November 1980, pp. 147–53; later published as 'Gender or Genius? The Women Artists of German Expressionism', as above, note 4.

6 Indeed the art historian Ingrid von der Dollen has recovered the careers of over 400 women artists who were active during the Weimar period (1919–33): Ingrid von der Dollen, *Malerinnen im 20. Jahrhundert: Bildkunst der 'verschollenen Generation' Geburtsjahrgänge 1890–1910*, Hirmer, Munich, 2000. She introduces her text by a methodological enquiry into '*die doppelte Verschollenheit*' (double absence) of women 'expressive realists', who, if they did not perish during the Third Reich, were marginalised and ignored in the post-war years by discriminatory cultural practices and the promotion of modernist abstraction in West Germany.

7 Not only was Paula Modersohn-Becker represented in the infamous '*Entartete Kunst*' exhibition in Munich in 1937, but also her works were seized from numerous collections. See Marion Ackermann, 'Paula Modersohn-Becker und München', in *Paula Modersohn-Becker 1876–1907 Retrospektive*, Helmut Friedel (ed.), Hirmer, Munich, 1997, pp. 21–22.

8 These were nos. 302 and 303 in the catalogue. See *The Blue Excavator (Der blaue Bagger)*, 1935–36, oil on canvas, 60.5 × 93 cm, Gabriele Münter- und Johannes Eichner-Stiftung, Munich, in *Gabriele Münter 1877–1962 Retrospektive*, Annegret Hoberg and Helmut Friedel (ed.), Städtische Galerie im Lenbachhaus, Munich, 1992, p. 292, no. 223.

9 Trude Brück (1902–1992), who was associated with the Düsseldorf circle of artists *Das Junge Rheinland*, suffered great trauma after almost all her works were destroyed in the bombing of Munich in 1943. She never resumed painting and turned her attention to restoration. See Annette Baumeister, 'Trude Brück', in *Rheinische Expressionistinnen*, Anke Münster (ed.), Verein August Macke Haus, Bonn, 1993, pp. 60–71; Von der Dollen, *Malerinnen im 20. Jahrhunderts*, p. 292.

10 See Hildegard Reinhardt, 'Olga Oppenheimer (1886–1941) – Malerin und Graphikerin', in *Rheinische Expressionistinnen*, as note 9, pp. 113–23.

11 Richard Evans cautions against this in his chapter 'From Hitler to Bismarck: "Third Reich" and Kaiserreich in recent historiography', in *Rethinking German History: Nineteenth-Century Germany and the Origins of the Third Reich*, Richard J. Evans (ed.), Unwin, London, 1987, pp. 55–93. Samuel Moyn, too, highlights the problems of a teleological interpretation of German history in his chapter, 'German Jewry and the question of identity: historiography and theory', *Leo Baeck Institute Yearbook*, Secker & Warburg, London, 1996, pp. 291–308.

12 Paul Fechter, *Der Expressionismus*, Piper, Munich, 1914. Though more interested in German contemporary artistic identity, Fechter devoted chapters to Cubism and Futurism.

13 See Stephanie Barron (ed.), *German Expressionism: The Second Generation 1915–1925*, Prestel, Munich, 1988; Joan Weinstein, *The End of Expressionism: Art and the November Revolution in Germany, 1918–19*, University of Chicago Press, Chicago, 1990.

14 Anton Lindner, 'Eine phänomenale Malerin oder was bleibt von der Worpsweder Kunst übrig?' *Neue Hamburger Zeitung*, 3 July 1914, p. 2: '*Paula Modersohn ist also Expressionistin. Sie ist der früheste Expressionist im deutschen Bereiche der modernen Malerei gewesen. Sie war die unerschrockene und unbeirrbare Vorläuferin eines schöpferischen Stils, der heute (sieben Jahre nach ihrem Tod und ungefähr zehn Jahre nach der Entstehung ihrer stärksten Werke) den weitesten Bezirk der bildenden Künste beherrscht. Ergo muß man sie (nicht nur vom kunstphilosophischen, auch vom sexualwissenschaftlichen Standpunkt aus) als erstaunliches Phänomen bezeichnen.*'

15 On the whole, one encounters prejudicial beliefs about women's abilities, as most flagrantly expressed in the words of the notorious Viennese writer Otto Weininger: 'A female genius is a contradiction in terms, for genius is simply intensified, perfectly developed, universally conscious male': Otto Weininger, *Sex and Character (Geschlecht und Charakter, Eine prinzipielle Untersuchung*, 1903), authorised translation from the sixth German edition, London and New York, 1910, p. 189.

16 In 1913, a selection of fifty letters and journal entries were assembled by the Bremen-based art historian Sophie Dorothea Gallwitz and published in *Güldenkammer* (Golden Chamber), a literary magazine that was sponsored by Ludwig Roselius's firm Kaffeehag: Paula Becker-Modersohn, 'Briefe und Tagebuchblätter', *Güldenkammer*, vol. 3, nos. 4–8, January–May 1913.

17 Fechter (1914) strove to inculcate a more masculine *Ausdrucksgefühl* (expressive feeling) in contemporary German art and constructed a genealogy for German artistic identity based on the anti-classical features of the Gothic past. By this time, the engendering of Impressionism as feminine, as celebrating sensory, passive experience, was well established in critical debates. See Magdalena Bushart, 'Changing times, changing styles: Wilhelm Worringer and the art of his epoch', in *Invisible Cathedrals: The Expressionist Art History of Wilhelm Worringer*, Neil H. Donahue (ed.), Pennsylvania State University Press, University Park, PA, 1995, pp. 69–85.

18 Hermann Bahr, *Expressionismus* (1916), Delphin Verlag, Munich, 1919, pp. 36–37: '*Sie malte, wie sie malen mußte, sie konnte nicht anders.*'

19 *Ibid.*, pp. 68–75. Bahr explicitly acknowledges the inspiration of both Alois Riegl (1858–1905) and Wilhelm Worringer (1881–1965).

20 *Ibid.*, pp. 75ff. For further commentary on Expressionist theory and the 'perception of the new' see Anke Sibille Daemgen, 'The Neue Secession in Berlin 1910–1914'. An artists' association in the rise of Expressionism', unpublished PhD, Courtauld Institute of Art: University of London, 2001, pp. 263ff.

21 Joan Weinstein, 'Expressionism in War and Revolution', in *German Expressionism: Art and Society*, Stephanie Barron and Wolf-Dieter Dube (ed.), Palazzo Grassi, Venice, 1997, p. 38.

22 Bahr, as note 18, pp. 110ff: '*Kampf der Seele mit der Maschine*'.

23 The major organisational platform
 of bourgeois women was the
 Bund Deutscher Frauenvereine or
 Federation of German Women's
 Associations (BDF). Founded in 1894,
 the BDF took on a new lease of life
 from 1899 onwards when Marie
 Stritt (1856–1928) headed the group
 and established a clearly defined
 radical stance. However the ousting
 of Stritt by Gertrud Bäumer (1873–
 1954) in 1910 led to the abandonment
 of the emancipative ideal by under-
 scoring the differences of female
 character, contrasting them with
 the male-dominated structures of
 industrial society. Particularly in the
 period leading up to and through
 the First World War, the BDF stressed
 the need for 'motherly' policies.
 Conceived as a cultural mission,
 maternalism remained in the
 spheres of social and moral rather
 than political reform. For a summary
 of the structures of the feminist
 movement in Germany during
 this period, see Richard J. Evans,
 'Liberalism and Society: the Feminist
 Movement and Social Change', in
 Rethinking German History, as
 note 11, pp. 221–47.
24 See Hermann Bahr, *Frauenrecht*,
 Lido, Pfingsten, 1912.
25 Wilhelm Hausenstein, 'Die Kunst in
 diesem Augenblick', *Der neue Merkur*,
 vol. 3, no. 2, 1919–20, pp. 117, 119–22,
 123, 125–6, as translated in *German
 Expressionism: Documents from the
 End of the Wilhelmine Empire to the
 Rise of National Socialism*, Rose Carol
 Washton-Long (ed.), University of
 California Press, Berkeley, 1995,
 pp. 281–83.
26 For further discussion on the
 gendering of mass culture see
 Andreas Huyssen, 'Mass Culture
 as Woman: Modernism's Other', in
 *After the Great Divide: Modernism,
 Mass Culture, Postmodernism*,
 Indiana University Press,
 Bloomington, 1986, pp. 44–62.
27 See Hans K. Roethel and Jean K.
 Benjamin, *Wassily Kandinsky:
 Catalogue Raisonné of the Oil
 Paintings*, vol. 1, *1900–15*, Sotheby's,
 London, 1982, p. 20.
28 Annegret Hoberg (ed.), *Wassily
 Kandinsky and Gabriele Münter:*

 Letters and Reminiscences 1902–1914,
 Prestel, Munich and New York, 1994.
29 Johannes Eichner, *Kandinsky und
 Gabriele Münter: Von Ursprüngen
 moderner Kunst*, Bruckmann,
 Munich, 1957, pp. 22, 282. Münter
 and Eichner developed their lives
 together from 1929 until his death
 in 1958.
30 Eichner, p. 38: '*Du bist hoffnunglos
 als Schüler – man kann dir nichts
 beibringen. Du kannst nur machen,
 was in dir gewachsen ist. Du hast alles
 von Natur. Was ich für dich tun kann,
 ist, dein Talent zu hüten und zu pflegen,
 daß nichts Falsches dazukommt.*'
31 On the woman/nature paradigm in
 the critical reception of Münter see
 Sabine Windecker, *Gabriele Münter:
 Eine Künstlerin aus dem Kreis des
 'Blauen Reiter'*, Reimer, Berlin, 1991;
 Reinhold Heller, *Gabriele Münter:
 The Years of Expressionism 1903–1920*,
 Prestel, Munich and New York, 1997,
 pp. 58–59.
32 See Paul Vogt, *Geschichte der
 deutschen Malerei im 20. Jahrhundert*,
 DuMont, Cologne, 1976. p. 58.
33 See Lesley Adelson, *Making Bodies
 Making History: Feminism and
 German Identity*, University of
 Nebraska Press, Lincoln and London,
 1993, pp. 16–17. In citing Rosalind
 Coward & John Ellis, *Language
 and Materialism: Developments in
 Semiology and the Theory of the
 Subject*, Routledge, London, 1977,
 pp. 80–81, Adelson seizes on Lacan's
 and Kristeva's notion of 'positionality'
 in the signifying practice. This is not
 to be confused with immutable fixity
 of position of the language-using
 subject (Lacan calls this the symbolic)
 but of the subject in relation to con-
 tradictory outside and ideological
 articulations (p. 155). From this we
 understand the constructed nature
 of the human subject.
34 Gabriele Münter, Year's motto
 recorded in pocket calendar, January
 1900, as cited in Gisela Kleine,
 *Gabriele Münter und Wassily
 Kandinsky: Biographie eines Paares*,
 Insel, Frankfurt am Main, 1990, p. 81:
 '*Je härtrer Kampf, desto größrer Sieg*'.
35 Eichner, as note 29, p. 26.
36 James C. Albisetti, 'Women and the
 Professions in Imperial Germany', in

 *German Women in the Eighteenth
 and Nineteenth Centuries*, Ruth-Ellen
 Joeres and Mary Jo Maynes (ed.),
 Bloomington, Indiana, 1986, p. 97,
 indicates that, as late as 1899, over
 a quarter of women teachers in
 Germany found employment as
 governesses.
37 Friedrich Nietzsche, *Also sprach
 Zarathustra. Ein Buch für Alle
 und Keinen*, Ernst Schmeitzner,
 Chemnitz, 1883–85, p. 107: '*Dass der
 Schaffende selber das Kind sei, das
 neu geboren werde, dazu muss er
 auch die Gebärerin sein wollen und
 der Schmerz der Gebärerin.*'
38 For photographs and drawings of
 the American visit see Kleine, as
 note 34, pp. 58–86.
39 W.J.T Mitchell, 'Imperial Landscape',
 in W.J.T Mitchell (ed.), *Landscape and
 Power*, University of Chicago Press,
 Chicago and London, 1994, p.17.
40 See Eddie Joe Guffee, *The Plainview
 Site*, Llano Estacado Museum,
 Plainview, Texas, 1979.
41 See 'Literaturbestand aus dem
 Nachlaß von Gabriele Münter',
 Gabriele Münter- und Johannes
 Eichner- Stiftung, Munich. The
 author, Charles Angelo Siringo
 (1855–1928), was born in Matagorda
 County, Texas, and his love of horses
 led him into the cattle business.
 In 1880 he joined a posse that was
 pursuing the notorious Billy 'the Kid'
 and, a year later, helped a group of
 Texas cattlemen dismantle a ring
 of horse thieves.
42 Geoff Eley, 'German History and
 the contradictions of modernity:
 the Bourgeoisie, the State and the
 Mastery of Reform', in Geoff Eley (ed.),
 *Society, Culture, and the State in
 Germany 1870–1930*, University of
 Michigan, 1996, p. 99.
43 See Russel A. Berman, 'Colonial
 Literature and the Emancipation of
 Women', in his *Enlightenment and
 Empire: Colonial Discourse in German
 Culture*, University of Nebraska
 Press, Lincoln and London, 1998,
 pp. 171–202.
44 See Kleine, as note 34, p. 73.
45 In later reminiscences Münter
 revealed her awareness of these
 restrictive practices in art education:
 'Gabriele Münter: über sich selbst',

 Das Kunstwerk, vol. 2, no. 7, 1948,
 p. 25.
46 Details of her attendance of
 the *Verein für Fraueninteressen*
 (founded 1894), meetings of which
 were held at the Photoatelier Elvira,
 can be found in Kleine, as note 34,
 p. 109.
47 For amplification of Münter's
 instruction in Munich, consult Heller,
 as note 31, pp. 50–55.
48 Wassily Kandinsky, *Die Nacht
 (Spazierende Dame)*, early 1903,
 gouache and white crayon on brown
 cardboard, 33.8 x 33.5 cm, no. 104
 in Vivian Endicott Barnet, *Vasily
 Kandinsky. A Colorful Life*, DuMont,
 Cologne, 1995.
49 Wassily Kandinsky, 'Rückblicke',
 Der Sturm, Berlin, 1913, in *Complete
 Writings*, as note 3, pp. 373–74.
50 Wassily Kandinsky, *Child and Dog
 (Kind und Hund)* 1904, oil on canvas,
 100 x 76 cm, location unknown,
 Catalogue Raisonné, as note 27,
 p. 132, no. 144.
51 See Endicott Barnett, as note 48,
 p. 127, fig. 13.
52 Kandinsky to Münter, 18.10.1905, as
 cited in Kleine, as note 34, p. 228.
53 Peg Weiss, 'Kandinsky in Munich:
 Encounters and Transformations',
 in *Kandinsky in Munich 1896–1914*,
 Solomon R. Guggenheim Museum,
 New York, 1982, p. 36.
54 Gabriele Münter- und Johannes
 Eichner-Stiftung, Munich: GMS 1128
 p. 5.
55 Gabriele Münter, 'Bekenntnisse und
 Erinnerungen', *Menschenbilder in
 Zeichnungen*, G.F. Hartlaub, Berlin,
 1952, no page reference.
56 Isabelle Jansen, 'Gabriele Münter in
 Paris 1906–1907', in *Gabriele Münter.
 Das druckgraphische Werk*, Helmut
 Friedel (ed.), Prestel, Munich, 2000,
 p. 43.
57 *Les Tendances Nouvelles*, vol. 3, no. 39,
 November, 1908, p. 835, cited in
 Kleine, as note 34, p. 259: '*C'est éton-
 nant de voir avec quelle rapidité Mlle.
 Munter se fait une place veritable-
 ment enviable. Elle déploie avec ses
 gravures, une supériorité dans la
 manière de regarder les choses, une
 exquisite féminine se mêlant à une
 rudesse consiente et curieuse.*'
 Reproduction of woodcuts in *Les*

Tendances Nouvelles, vol. 4, no. 40, January 1909, pp. 872, 873, 875, 879.

58 See Endicott Barnett, as note 48, nos. 73, 174 (GMS 776/1; GMS 776/2), pp. 144.

59 For a comprehensive account of the social and institutional status of women artists, see Renata Berger, *Malerinnen auf dem Weg ins 20. Jahrhundert: Kunstgeschichte als Sozialgeschichte*, Cologne, 1982, pp. 58ff.

60 *Simplicissimus*, vol. 6, no. 15, 1901, p. 117: 'Sehen Sie, Fräulein, es gibt zwei Arten von Malerinnen: die einen möchten heiraten und die andern haben auch kein Talent'.

61 John Gage, 'Photographic Likeness', in Joanna Woodall (ed.), *Portraiture: Facing the Subject*, Manchester University Press, Manchester and New York, 1997, p. 122.

62 'Literaturbestand aus dem Nachlaß von Gabriele Münter', Gabriele Münter- und Johannes Eichner-Stiftung, Munich: O.S. Fowler, *The Illustrated Self-Instructor in Phrenology and Physiology with one hundred Engravings and the Chart of Character*, Fowler & Wells, New York, 1857. Frontispiece: 'C.F. Münter as given by W.H. Barker'.

63 Gabriele Münter, 'Gabriele Münter: über sich selbst', *Das Kunstwerk*, vol. 2, no. 7, 1948, p. 25.

64 Volker R. Berghahn, *Economy, Society and Culture of Imperial Germany 1870–1914*, Providence and Oxford, 1994, pp. 15–17, pinpoints the intense period of economic expansion to the years between 1893 and 1913.

65 *Kölner Tageblatt*, 9 January 1908, as cited in Margarethe Jochimsen, 'Frühe Holz-und Linolschnitte in Bonn und Köln. Gabriele Münters erste Einzelausstellungen', in *Gabriele Münter. Das druckgraphische Werk*, 2000, p. 50: '. . . leuchtenden Eindrucksskizzen, auf Parise Art gepatz Es liegt eine besondere Kühnheit und ein ungewöhnlicher Strebensernst in diesen ohne jede Rücksicht auf die Durchschnitts-anschauung geschaffen Bildchen.'

66 For the most up-to-date publication see Annegret Hoberg and Helmut Friedel (ed.), *Der Blaue Reiter und das neue Bild: von der 'Neuen Künstler-vereinigung München' zum 'Blaue Reiter'*, Prestel, Munich, 1999.

67 See Nina Lübbren, *Rural Artists' Colonies in Europe 1870–1910*, Manchester University Press, Manchester, 2001, p. 124. Lübbren reveals that by the time that Modersohn-Becker settled in Worpswede in 1898 the group had enjoyed considerable success in charting these characteristic landscape motifs.

68 A comprehensive account of this reception can be found in Walter Feilchenfeldt, *Vincent van Gogh and Paul Cassirer Berlin: The reception of van Gogh in Germany from 1901 to 1914*, Uitgverij Waanders, Zwolle, 1988.

69 See Annegret Hoberg, *Gabriele Münter*, Prestel, 2003, pp. 18–19.

70 Heller, as note 31, pp. 67–82, amplifies on the programme of modernisation and refurbishment undertaken in Murnau, as recently as 1906, prior to the artists' discovery of the town.

71 Hoberg, as note 28, pp. 97–99: Münter's letters to Kandinsky dated 8 December 1910 and 12/13 December 1910.

72 Hoberg and Friedel, *Gabriele Münter 1877-1962 Retrospektive*, as note 7, p. 264, no. 63: '*Die Werefkina malte ich 1909 vor dem gelben Sockel meines Hauses. Sie war eine pompöse Erscheinung, selbstbewußt, herrisch, reich gekleidet, mit einem Hut wie ein Wagenrad, auf dem allerhand Dinge Platz hatten*'.

73 Further examination of Marianne Werefkin's works of this period can be found in Shulamith Behr, 'Veiling Venus: gender and painterly abstrac-tion in early German modernism', in *Manifestations of Venus. Art and Sexuality*, Caroline Arscott and Katie Scott (ed.), Manchester University Press, Manchester, 2000, pp. 126–41.

74 Anon., *Rheinisch-Westfälische Zeitung*, 8 May 1910: '*Gabriele Münter imitiert buchstäblich die Zeichnungen kleiner Kinder, von denen die modernste Pädagogik zu viel Wesens gemacht hat – diese Ungeniertheit, die jedem Sinn für Perspektive und natürliche Formen hohnspricht und ekelhafte Fratzen als menschliches Gesichter, die grüne Flecken für Augen, eckige Klötze für Nasen, breite Schlitze für Münder ausgibt, muß abgelehnt werden. Vor solchem Anblick muß die breite Masse der Besucher bewahrt werden; muß auch sie nicht irre werden? – Der Grundsatz "Sensation um jeden Preis" gehört nicht in eine Kunstausstellung.*'

75 Barbara Wörwag examines the significance of child art to Münter and Kandinsky in her essay, '"There is an Unconscious, Vast Power in the Child": Notes on Kandinsky, Münter and Children's Drawings' in *Discovering Child Art. Esays on Childhood, Primitivism and Modernism*, Jonathan Fineberg (ed.), Princeton University Press, New Jersey, 1998, pp. 68–94.

76 Hoberg, as note 28, pp. 45–46: Münter, Diary, 1911.

77 Annegret Hoberg, 'Neue Künstler-vereinigung München und Blaue Reiter', in Hoberg and Friedel (ed.), *Der Blaue Reiter und das neue Bild*, as note 66, p. 13–14. Jawlensky spent short periods in Normandy and Paris in 1903 and 1905 and absorbed the impact in his painting of Van Gogh, Gauguin and the Nabis. In 1907, the painter monk Willibrod Verkade worked in Jawlensky's studio in Munich, thus endorsing the lessons of Gauguin and Paul Sérusier.

78 Shulamith Behr, *Expressionism*, Tate Gallery Publishing, London, 1999, p. 41.

79 Arthur Kroker and David Cook, 'Parson's Foucault', in *The Post-Modern Scene, Excremental Culture and Hyper-Aesthetics*, St Martin's Press, New York, 1986, p. 228, as cited in Linda Nochlin, *Women, Art and Power and other Essays*, Thames & Hudson, London, 1989, p. 8. Also see Fiona Griffiths, 'The Self-Image as Projection and Masquerade in Selected Works by Gabriele Münter and Paula Modersohn-Becker', Special Option Essay, Courtauld Institute of Art Library, 1990, note 73.

80 Hoberg, as note 28, p. 99: Münter, letter to Kandinsky, 12/13 December 1910.

81 *Ibid.*, pp. 18–19.

82 Theodor Lessing, *Weib, Frau, Dame*, Otto Emelin, Munich, 1910, p. 122.

Lessing (1872–1933) arrived in Schwabing in 1894 to complete his medical studies, only to switch to studying literature, philosophy and psychology, writing his doctoral thesis on a Russian logician. In 1907, he became a *Privatdozent* of Philosophy at the Technical University in Hanover.

83 Münter's self-portraiture is explored in greater detail in Shulamith Behr, 'Die Arbeit am eigenen Bild: Das Selbstporträt bei Gabriele Münter', in Hoberg and Friedel, *Gabriele Münter 1877–1962 Retrospektive*, as note 7, pp. 85–90.

84 For an inverse discussion of the interior genre in relation to a different context consult Tag Gronberg, 'The Inner Man: Interiors and Masculinity in Early Twentieth Century Vienna', *Oxford Art Journal*, vol. 24, no. 1, 2001, pp. 67–88.

85 The context of this commission is discussed in greater depth in Shulamith Behr, 'Gabriele Münter. Portrait of Anna Aagaard', in *National Art Collections Fund Annual Report*, Marina Vaizey (ed.), 1992, pp. 56–59.

86 For a discussion of images of women and smoking lore during the nine-teenth century see D. Mitchell, 'The "New Woman" as Prometheus', *Woman's Art Journal*, vol. 12, no. 1, Spring/Summer 1991, pp. 3–9.

87 See Jacques Derrida, 'La Différance', in *Marges de la philosophie*, Editions de Minuit, Paris, 1972. Translated in Jacques Derrida, *A Derrida Reader: Between the Blinds*, Peggy Kamuf (ed.), Harvester Wheatsheaf, New York and London, 1991, pp. 59–79.

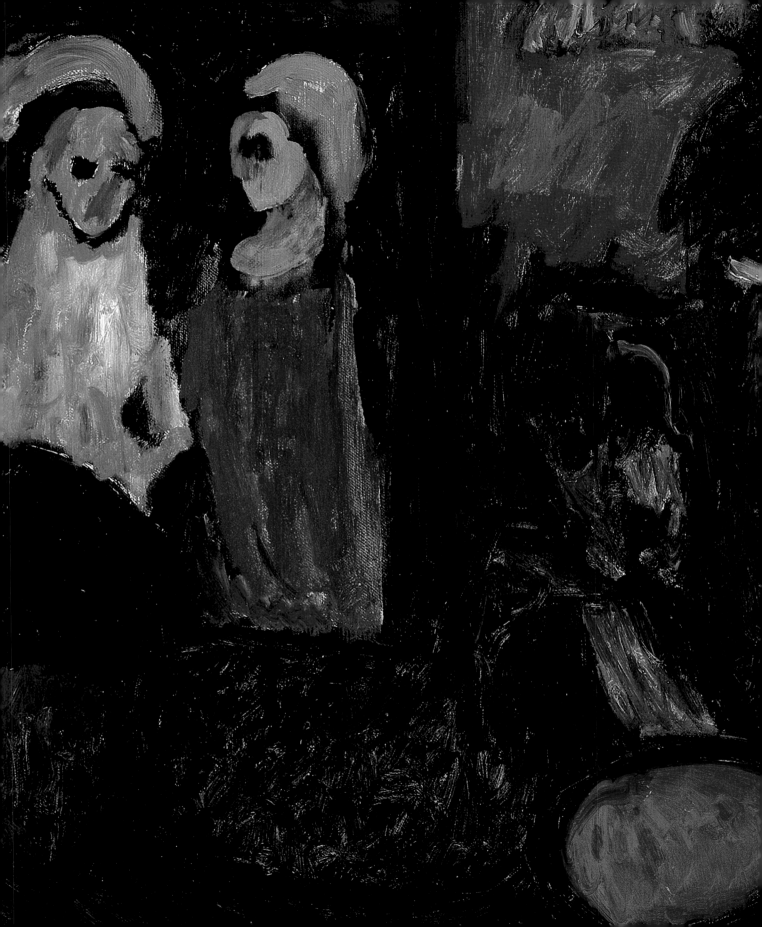

Catalogue

Barnaby Wright

1. Avenue in the Park St-Cloud
Allee im Park von Saint Cloud

1906

Oil on canvas
40.5 × 50.5 cm
Städtische Galerie im Lenbachhaus, Munich

Between 1906 and 1907, Gabriele Münter lived for almost a year in Sèvres with Wassily Kandinsky, in rented rooms in a house at 4 petite rue des Binelles, near to the Park St-Cloud. She spent a significant amount of her time in this popular park producing numerous *plein-air* studies, usually on small pieces of cardboard. This painting on canvas is one of the largest and most technically accomplished of her Sèvres works and suggests her growing confidence as an artist. The following year she launched her professional artistic career by exhibiting a selection of these paintings at the Salon des Indépendants in Paris.

Avenue in the Park St-Cloud demonstrates Münter's profound artistic engagement with Impressionist modes of representation. She captures the effects of the dappling play of sunlight passing through the dense canopy of trees by using a palette knife to build up a rich paint surface from small dabs and strokes of carefully graded colours, ranging from deep greens through to violets, pinks and whitish yellows. Münter learned to use the palette knife in this impressionistic manner several years earlier in Kandinsky's painting classes at the Phalanx School in Munich. She also joined the classes' summer excursions to Kallmünz and Kochel where, under Kandinsky's guidance, she painted her first *plein-air* landscapes. By the time Münter came to paint *Avenue in the Park St-Cloud* she had begun to explore the autonomous character of paint and colour within the framework of representation. The painting maintains a certain fidelity to the perceived appearance of the scene. However, her technique of applying regular pastose dabs to every inch of the canvas emphasises the two dimensionality of the picture plane and the material character of the paint in ways that disrupt our impression of being there on that summer's day in St-Cloud. The subtle inclusions of some dabs of non-local colour, such as the vibrant pinks and glowing blues, further accent the autonomy of the painted mark within the picture.

These artistic concerns were central to contemporary developments in progressive European painting that emerged from a shared legacy of Impressionism and Post-Impressionism, notably in the work of the Fauves, who had made a dramatic impact at the Salon d'Automne in 1905 and again in 1906; the latter an exhibition Münter most likely visited whilst living in Sèvres. But if this painting registers those issues at the forefront of contemporary artistic dialogue, then it does so without obviously relinquishing earlier forms of Impressionism. In the following few years Münter would effect a more radical stylistic break from *Avenue in the Park St-Cloud*, however, whilst her later work stressed the expressive autonomy of painting, she would remain sensitive to the importance of conveying an impression of the scene before her.

2. **Still Life with Vase of Brushes**
 Stilleben mit Pinselvase

1906 – 07

Oil on canvas
55.5 × 46 cm
Gabriele Münter- und Johannes Eichner-Stiftung, Munich

Still life was an important genre for Münter that she returned to in various guises throughout her career, sometimes focusing intensively on collections of significant objects (see cat. 17), or using still-life elements to contribute to the psychological intensity of portrait paintings (see cat. 21). In many ways *Still Life with Vase of Brushes*, one of her first serious attempts at the genre, anticipates these later developments. Although this work is in part an Impressionist-inspired study of the effects of light reflecting off the curvaceous surfaces of the vase, her arrangement of the objects, most especially the somewhat surprising central motif of a 'bunch' of brushes (in place of flowers), seems so self-conscious as to invite a symbolic reading.

Viewing the content of *Still Life with Vase of Brushes* as more than the raw material for a technical exercise in light effects requires a certain degree of speculation, because Münter's juxtapositions of objects here tread an uncertain line between symbolic significance and purely aesthetic arrangement. However, the connection between the vase of brushes and the painting on the wall behind is particularly intriguing. This framed picture is likely to be her small oil sketch *Park St-Cloud in Autumn* of 1906.[1] The bristles of some of the brushes seem to connect with the painted surface of the little sketch, creating a visual pun and perhaps also suggesting that the vase of brushes be seen as a representation of the artist herself – still life turned self-portrait. The juxtaposition of the domestic objects on the table with the tools of her profession in the vase adds a further dimension to a reading of this painting's autobiographical significance, particularly given that it is likely to have been painted in her Sèvres apartment. Moreover, the contemporary associations of the 'domestic' with the 'feminine' and the 'professional' with the 'masculine' make this a deeply gendered image in the context of Münter's uncertain status as a woman artist at that time. Seen in this light, her replacement of the flowers with brushes takes on a heightened significance.

The vase of brushes may also relate symbolically to her artistic practice itself, specifically to the relationships between the appearance of nature and the artifice of its painted representation that her contemporary landscape paintings address (see cat. 1). Perhaps more obviously than any other artistic genre, still life involves the contrived organisation of objects from the real world, a conflation of artifice and reality that, when working from actual objects, begins prior to the execution of the painting itself. In this painting, where brushes stand in for flowers, the contrivance of still life – and by extension the artifice of artistic representation – is made explicit.

1 This painting was formerly with Galerie Thomas, Munich, and is reproduced in *Expressionismus Klassische Moderne*, Galerie Thomas, Munich, 2003, pp. 70–71. It is listed in the Gabriele Münter- und Johannes Eichner- Stiftung as *Park St. Cloud im Herbst*, 1906, no. L571.

3. Portrait of a Young Boy
Knabenporträt

1908

Oil on board
76 × 51.8 cm
Gabriele Münter- und Johannes Eichner-Stiftung, Munich

This previously unpublished portrait is remarkable for its level of psychological intensity, conveyed by expressive distortions of a sort seldom repeated in Münter's work. The theme of children occupied many of Münter's portraits between 1908 and 1910, especially those of young girls, which she exhibited in a series at Herwarth Walden's *Sturm* Gallery in 1913 (see fig. 23, p. 47). However, in stark contrast to those works, which portray their young female sitters as embodiments of assured innocence, *Portrait of a Young Boy* expresses a disturbing sense of anxiety and threat. This is matched at the level of execution by Münter's anxious brushwork, which seems in places to have been scrubbed on to the surface of the board, creating a patchy finish of thinly painted strokes.

The young boy's exaggerated watery blue eyes engage the viewer with a stare of both sorrow and fear which is carried through to his hunched posture and the nervous fumbling of his hands at the opening of his ill-fitting jacket. However, it is the uncertainty of the boy's situation that is the most unsettling feature of the painting. It is possible that he is a peasant boy that Münter asked to sit for her during one of her excursions to Bavarian towns and villages in 1908, and that his discomfort arises from the unfamiliarity of the encounter. However, like Edvard Munch's famous study of adolescence, *Puberty*, 1895, which offers a striking comparison, Münter's *Portrait of a Young Boy* seems to provoke more general themes of vulnerability and uncertainty. Whilst Münter's painting does not carry the same charge of sexual danger as Munch's image, the anxiety of this boy seems gendered in different ways. His spread-legged posture is a typical assertion of masculine confidence but this is, of course, quickly undone by the nervousness of the rest of his body, and his apparently rough working clothes contrast with the sickliness of his pale face and hands. In this way, the painting carries certain anxieties of manhood as much as it represents the discomfort of a young boy being asked to sit still.

It is perhaps significant, as Reinhold Heller has noted, that whilst Münter exhibited her portraits of young girls, the portraits of young boys such as this one remained largely unseen.[1] Perhaps she found it difficult to establish a coherent symbolic typology of boyhood and to a certain extent she seemed to favour a portraiture that synthesised typology and individuality (see cat. 4, 20–21). This might begin to explain why the ambiguities and emotional distortions of *Portrait of a Young Boy* did not prove to be an enduring model for her future portraits.

1 Reinhold Heller (ed.), *Gabriele Münter: The Years of Expressionism 1903–1920*, exh. cat., Milwaukee Art Museum and elsewhere, Prestel, Munich and New York, 1997, p. 178 (chapter 4, note 16).

4. **Fräulein Mathilde**
 Fräulein Mathilde

1908 – 09

Oil on board
76.5 × 50.7 cm
Gabriele Münter- und Johannes Eichner-Stiftung, Munich

Fräulein Mathilde was Kandinsky's housekeeper at the Munich apartment
that he acquired in 1908. Although Münter rented a studio and room at the
Pension Stella elsewhere in the city, they were living together as an unmarried
couple; Kandinsky had not yet obtained a divorce from his first wife Anja
Semjakina. In the context of Kandinsky and Münter's potentially scandalous
relationship, the housekeeper Mathilde represented a norm of bourgeois
domesticity whilst presumably being privy to the unconventional living
arrangements of the couple. It is perhaps significant that Münter should
choose to portray her standing at a doorway in the manner of seventeenth-
century Dutch genre painting, in which servants carry moralising meanings
that mediate between the private and public spheres.

Fräulein Mathilde marks the beginnings of a portrait style that Münter
would develop over the following decade, characterised by the reduction of
form and colour and the distillation of individual appearance to an essential
level. Here, the predominance of blue coloration allows for significant
elements such as Mathilde's face and arms to achieve particular prominence.
However, the colour blue held particular spiritual and mythic significance
for Kandinsky and Münter may have considered it the appropriate colour
with which to depict his home.

The painting also anticipates Münter's preoccupation with the representa-
tion of women, especially her later Swedish portraits of women in interiors,
which express a similar sense of distanced contemplation to that conveyed
by Mathilde.

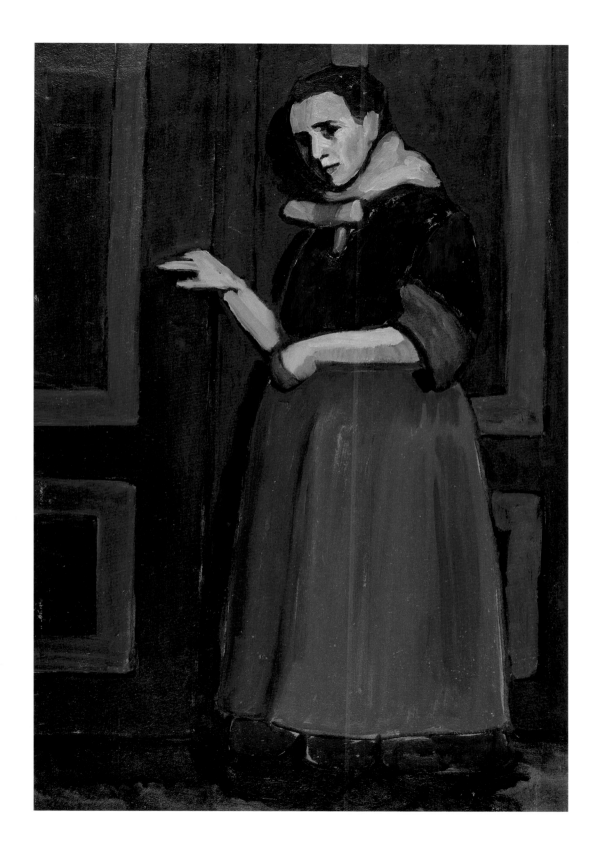

5. **View of the Murnau Moors**
Blick aufs Murnauer Moos

1908

Oil on board
32.7 × 40.5
Städtische Galerie im Lenbachhaus, Munich

View of the Murnau Moors is one of a series of landscapes produced during Münter's first summer in Murnau with Kandinsky, Marianne Werefkin and Alexej Jawlensky. With these paintings she broke away dramatically from her earlier Impressionist-inspired technique and assumed aesthetic values that soon became synonymous with the term 'Expressionism'. In 1911, writing in her diary, Münter recalled this extraordinary stay in Murnau: 'After a short period of agony I took a great leap forward, from copying nature – in a more or less Impressionist style – to feeling the content of things – abstracting – conveying an extract.

'It was a wonderful, interesting, enjoyable time with lots of conversations [. . . .] I particularly enjoyed showing my work to Jawlensky – who praised it lavishly and also explained a number of things to me – passed on what he had experienced and learned – talked about 'synthesis' [. . . .] I did a whole heap of studies. There were days when I painted 5 studies [. . .] and many when I managed 3 and a few when I didn't paint at all.'[1]

The sense of rapid creative activity is palpable in *View of the Murnau Moors*. Münter painted directly on to the unprimed strawboard, boldly sketching in the basic outlines in black paint before filling them with broad brush strokes of vibrant green, blue and purple, leaving gaps of bare board in between. The vast expanse of the Murnau Moors, which stretch out from the cultivated lowlands, dotted with storage huts, through uncultivated woodland and upwards to the Bavarian Alps, evade straightforward visual comprehension and must have seemed an ideal subject with which to explore the expressive possibilities of her new 'abstracting' techniques. *View of the Murnau Moors* can be seen as an arrangement of abstracted passages of painting, fitted only loosely into a convincing perspectival framework. In this way Münter signals her commitment to 'conveying an extract' as opposed to the sort of seamless visual totality that characterised her impressionistic palette-knife works (see cat. 1). However, she also intensifies her 'Impressionist' commitment to the effects of atmospheric conditions, particularly apparent in her treatment of the rising mist, which seems to dissolve the mountains into thin air, prompting associations with the symbolism of Romantic landscape painting.

Jawlensky's encouragement and his practical commitment to the concept of 'synthesis', the distillation of colours and forms to their essence to achieve a purer, more vital, artistic expression, was certainly an influential part of Münter's 'leap forward'. Moreover, Jawlensky, who had had contact with both Paul Sérusier and Matisse, provided a tangible link with an artistic trajectory that ran from Paul Gauguin through to Fauvism and beyond, imbuing

Fig. 38 Gabriele Münter, *Study from Holland*, 1904–05
Oil on canvas-covered board
Gabriele Münter- und Johannes Eichner-Stiftung, Lenbachhaus, Munich

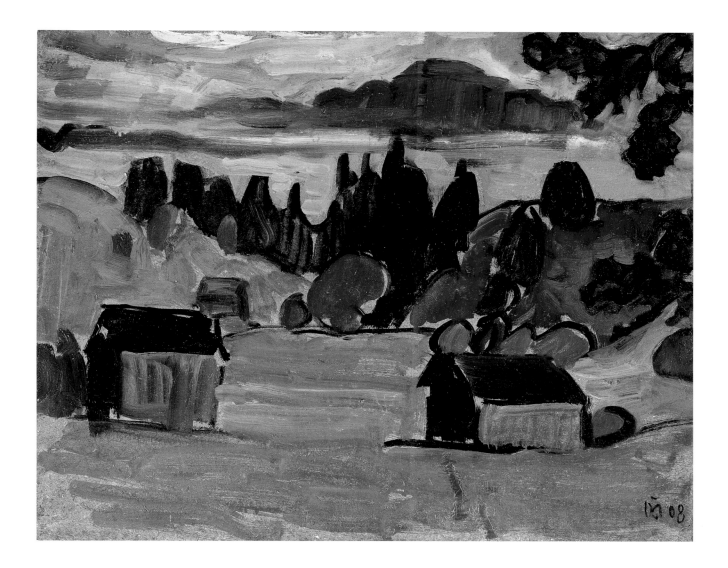

Münter's new work with progressive purpose. However, *View of the Murnau Moors* was also rooted in her earlier work. The *cloisonné* effect of black outlining had been a distinctive feature of her recent printmaking practice (see fig. 28), and the simplified coloration, applied in bold sweeping strokes, is prefigured in earlier paintings such as *Study from Holland*, 1902 (fig. 38). That Münter responded so rapidly and adroitly to Jawlensky's example with *View of the Murnau Moors* owed more to a decade of sustained artistic development than it did to those feminine stereotypes of 'natural instinct' and 'intuition' which quickly came to frame the reception of her work from this period onwards.

1 Reprinted in translation in Annegret Hoberg, *Wassily Kandinsky and Gabriele Münter: Letters and Reminiscences, 1902–1914*, Munich and New York, 1994, pp. 45–46.

6. Street in Murnau
Murnauer Strasse

1908

Oil on board
33 × 41 cm
Private Collection
(on extended loan to the Courtauld Institute of Art Gallery, London)

Street in Murnau belongs to the same group of paintings as *View of the Murnau Moors* (cat. 5), yet it extends considerably the abstract qualities of that work. In places Münter's initial sketched-in black outlines are breached by vigorous strokes of the brush, loaded with vibrant coloured paint, breaking down and blurring distinctions between line, form and colour. Discussions about the nature and symbolic force of the 'synthesis' of these three components of painting were central to the artistic collaboration between Münter, Kandinsky, Jawlensky and Werefkin that was quickly established in Murnau at this time. *Street in Murnau* connects strongly with Kandinsky's stress on liberating colour from its representational function, ideas he published in his 1912 treatise, *Concerning the Spiritual in Art*. However, in her later reminiscences, Münter made it clear that Jawlensky's artistic example provided the most direct 'formal model' for her own work at this time, although Kandinsky's role was, in other ways, the more profound: 'If I have a formal model – & in a way that was certainly the case 1908–13, it is no doubt Van Gogh via Jawlensky & his theories. (His talk of synthesis.) This cannot, however, be compared to what Kandinsky was for me. He loved, understood, protected and nurtured my talent.'[1]

In some ways *Street in Murnau* came closer to abstraction than Kandinsky's contemporary Murnau paintings and it is perhaps more comparable to his later paintings of the town. However, Münter did not share Kandinsky's programmatic drive towards abstraction, but, like Vincent van Gogh, maintained an absolute commitment to rooting her work in the reality of a particular object or scene. For all its abstract qualities, Münter's *Street in Murnau* strives to express the character of the town itself. The abstract formal relationships of shape and colour relate directly to the expression of her idealised vision of harmony between architecture and nature in Murnau, evoking a sense of rural timelessness and authenticity.

Münter was part of a modern influx to Murnau and in buying a recently built house on its outskirts the following year she contributed to the rapid expansion of the town, which would nearly double in size by 1914 (see cat. 12). The modernisation of Murnau, which began in 1906, was overseen by Professor Emanuel von Seidl, who revived the local craft traditions of vernacular architecture in an attempt to regenerate the town as an authentic Bavarian village. Münter thus bought into this revivalist ideal and, although the aesthetics of *Street in Murnau* may have seemed anathema to others seeking a rural retreat in the town, its idealising impulse was consistent with the wider ideology of 'rural authenticity' that was shaping the modernity of Murnau itself.

1 Gabriele Münter, note for Johannes Eichner, c. 1933, reprinted in translation in Annegret Hoberg (ed.), *Wassily Kandinsky and Gabriele Münter: Letters and Reminiscences, 1902–1914*, Prestel, Munich and New York, 1994, p. 52.

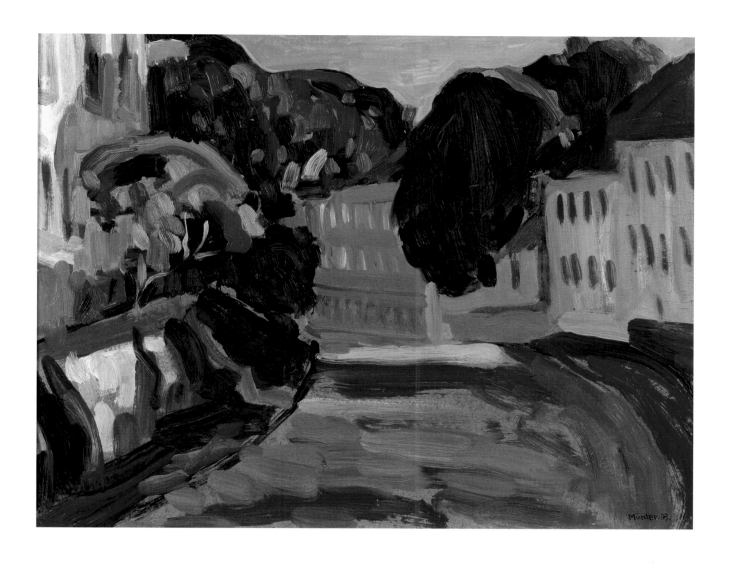

85

7. Grave Crosses in Kochel
Grabkreuze in Kochel

1909

Oil on board
40.5 × 32.8 cm
Städtische Galerie im Lenbachhaus, Munich

Münter painted *Grave Crosses in Kochel* in February 1909 whilst she and Kandinsky were staying with the Russian composer Thomas von Hartmann and his wife Olga. Münter had visited the town with Kandinsky several years earlier, in the summer of 1902, as a member of his Phalanx school painting class, during which trip she produced her first *plein-air* paintings under his tutelage. As if to mark the importance of painting directly from nature to their joint artistic development, Kandinsky and Münter produced numerous studies of Kochel during their two-week stay with the Hartmanns, focusing intensely on the visual effects of the snow that enveloped the town (fig. 39). For this brief period their painting styles overlapped as both explored the use of blue to depict the optical properties of snow, powerfully expressing its weight and depth, as well as its icy chill, over the Kochel landscape.

Grave Crosses in Kochel is an unusual composition and unlike Münter's other landscape work. Indeed, by focusing in so closely on the crosses Münter creates an ambiguous sense of scale, such that the painting might almost be a still life, akin to her contemporary still-lifes of small crucifixes from her burgeoning collection of Bavarian folk art. Her interest in the votive and devotional objects of Catholicism was sparked by Jawlensky, who had introduced her to the Bavarian and Bohemian tradition of *Hinterglasmalerei* (painting behind glass), examples of which she also began to collect. As with her later works that focus intensely upon devotional religious objects, such as *Dark Still Life (Secret)*, 1911 (cat. 17), in *Grave Crosses in Kochel* it is the nature of spiritual devotion itself that forms the subject-matter of the painting, with the viewer fundamentally implicated in the act of contemplation as he or she looks upon the work.

Although related to her still lifes, *Grave Crosses in Kochel* engages strongly with the Romantic landscape tradition of Caspar David Friedrich, most especially with his *Cross on the Mountain*, 1802, which was the first altarpiece in Christian art to be conceived in terms of a pure landscape. Like Friedrich, Münter uses the scene's natural features to convey spiritual meaning, with the drifting snow forming a shroud over the graves. However, by cropping the statuette of the Virgin Mary on the wall behind the crosses, Münter dramatically distances any such spiritual meanings from the orthodoxy of the Catholic Church, marking out *Grave Crosses in Kochel* as a fundamentally personal artistic vision.

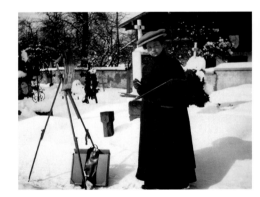

Fig. 39 Gabriele Münter painting in Kochel graveyard
Gabriele Münter- und Johannes Eichner-Stiftung, Munich

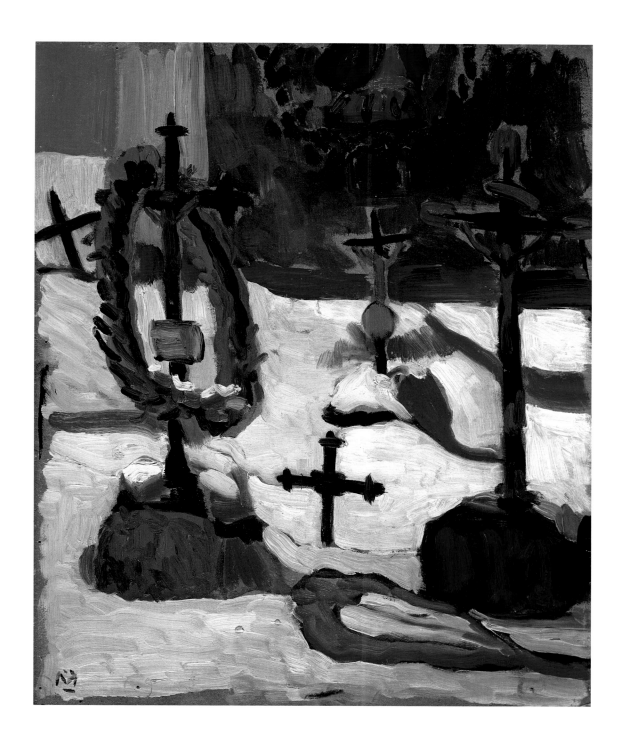

8. **Portrait of a Young Woman in a Large Hat (The Polish Woman)**
 Bildnis einer Jungen Dame mit Großem Hut (Polin)

1909

Oil on card
72.2 × 48.8 cm
English private collection
(on extended loan to the Courtauld Institute of Art Gallery, London)

Portrait of a Young Woman in a Large Hat (The Polish Woman) is one of a
number of ambitiously large related portraits that Münter produced between
1908 and 1909. These works revitalised female portraiture and count among
her most important contributions to European modernism. In its bust-length
profile and simplified, black-outlined form, this painting is closely related
to the more famous of these, her celebrated *Portrait of Marianne Werefkin* of
1909 (fig. 33, p. 61). However, the woman in this portrait remains anonymous,
her broad identification as 'The Polish Woman' deriving from a note written
much later by Johannes Eichner on the back of another portrait of the same
sitter. It is possible that Münter met the sitter in Murnau's Griesbräu inn –
a fellow traveller to the countryside – or else in Munich; in either case her
well-dressed appearance and elaborate hat suggest that she was a woman of
urban sophistication like Münter herself.

Although anonymous, this woman shares those same characteristics
of conviction and determination, conveyed through the intensity of her
far-away stare and the solidity of her form, that were defining features of
Münter's portraits of women during this period. Münter's treatment of the
female body and women's clothing is a particularly significant part of these
portraits. In contrast to prevalent artistic representations of women, which
intensified, in various ways, the revelation of the naked female body (notably
by the *Brücke* artists), Münter accentuates the cape-like quality of the Polish
woman's clothing so as resolutely to conceal her form, and so that her head
sits atop a mountain-shaped peak of boldly coloured material. This large
swathe of clothing provides a prominent space for passages of pure painting,
freed from the necessity of rendering bodily shape. In this way Münter
conflates a sense of artistic liberation with the determined image of this
modern woman whose intense gaze and gently knowing smile speaks of
potential and possibility, values which, unlike her later more introspective
portraits of women in interiors (see cat. 20–21), are not circumscribed here
by any physical surroundings.

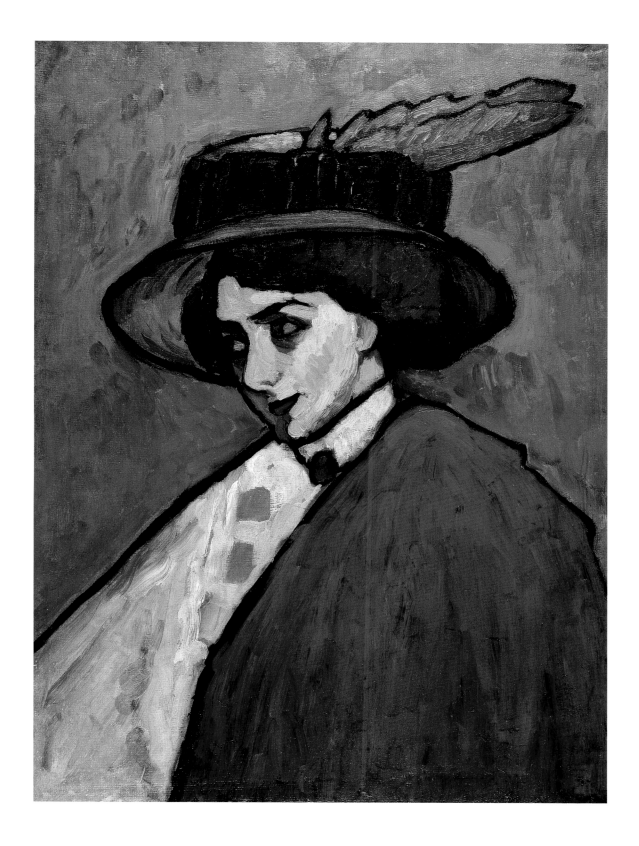

9. **Jawlensky and Werefkin**
Jawlensky and Werefkin

1909

Oil on board
32.7 × 44.5 cm
Städtische Galerie im Lenbachhaus, Munich

Münter spent much of the spring and summer of 1909 in Murnau with Kandinsky, Jawlensky and Werefkin. The four artists had established their own avant-garde exhibiting association, the *Neue Künstlervereinigung München* (NKVM), earlier in the year and so this period in Murnau was imbued with a heightened sense of artistic collaboration and purpose as they prepared for the NKVM's first exhibition, scheduled for December. Münter's double portrait, *Jawlensky and Werefkin*, is a confident summation of her rapid artistic development over the previous months – a development that owed much to the influence of her two subjects, shown lying in this Murnau meadow.

Here the searching, somewhat fugitive, quality of much of her other work gives way to a solidity of colour and form, matched by the precision of its composition. This is partly due to the fact that Münter painted it in the studio from an initial detailed pencil drawing (fig. 40). In the drawing, Münter sketches in the details and expression of Jawlensky's face, which are omitted in the finished painting. Although unusual in Münter's work, this 'effacement' was entirely consistent with Jawlensky's own artistic practice of 'synthesis', simplifying form to its essential characteristics. Blanking their faces also serves to monumentalise the figures, rendering them as timeless as the surrounding landscape, whilst allowing them to represent a generalised utopian ideal of harmony between man, woman and nature.

Münter's *cloisonné* technique of outlining in black before filling in with colour, endorsed by her contact with Jawlensky, is a particularly prominent feature of this painting. It connects strongly with similar glass painting techniques employed in traditional Bavarian *Hinterglasmalerei*, which Münter not only collected avidly (see cat. 7) but was also beginning to produce herself, copying closely their devotional religious imagery. The simplified folk-art

Fig. 40 Gabriele Münter, Study for *Jawlenksy and Werefkin*, 1909
Pencil on paper
Gabriele Münter- und Johannes Eichner-Stiftung, Lenbachhaus, Munich

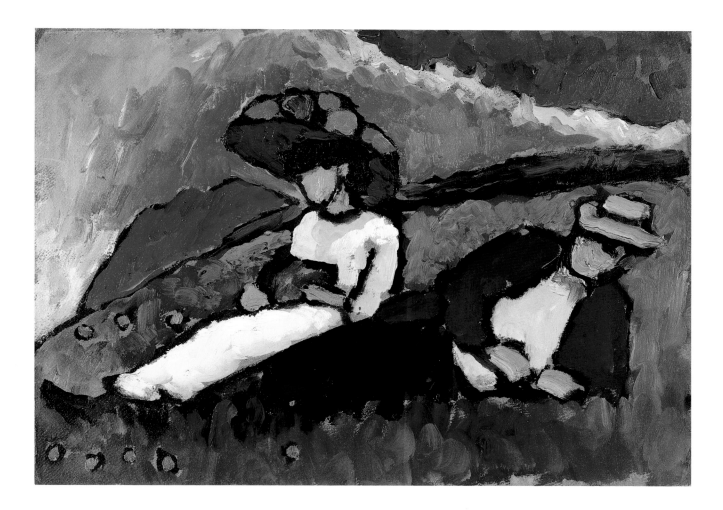

aesthetic of these devotional images is echoed in *Jawlensky and Werefkin*, investing the painting with the values of rural authenticity and spiritual purity that were a fundamental part of Münter's revivalist commitment to Murnau and its folk-art traditions.

However, Werefkin's exaggerated and brightly coloured hat strikes a slightly discordant note within the context of a reading of the painting's 'authentic' traditional values. Although Münter simplifies all the elements of the picture to an essential level, the hat retains its dominating presence as a decorative accessory. Surviving photographs of Werefkin in Murnau (see p. 12) show that she had a penchant for elaborate hats, which, in stark contrast to the simple bonnets worn by local women, clearly marked her out on Murnau's streets as a rather flamboyant bourgeoise visitor from the city, and, in its small way, also signalled the encroachment of modernity into the town (see cat. 6). In *Jawlensky and Werefkin* the hat also resembles a palette of paint colours, the very colours used in other areas of the painting, thus fusing the hat's gender and class conno- tations with Werefkin's identity as an artist. If the painting constructs a utopian ideal then it does so in ways that register the complex, and to some extent unresolved, process of artistic and social negotiation that went into its making.

10. **Listening (Portrait of Jawlensky)**
 Zuhören (Bildnis Jawlensky)

1909

Oil on board
49.7 × 66.2
Städtische Galerie im Lenbachhaus, Munich

Münter later recalled that this extraordinary portrait caught Jawlensky "with an expression of puzzled astonishment on his chubby face listening to Kandinsky explaining his latest theories of art".[1] Here her 'synthetic' techniques of radically simplifying form and colour, which she had developed in relation to landscape painting the previous year, are deployed to create a powerful caricature. She reduces Jawlensky's face to a shorthand of dots and dashes in order to express his bewilderment, whilst the exaggerated sweep of his body towards the right-hand side of the picture (where Kandinsky is presumably talking) is achieved by a simple broad stroke of pink, comically paired with the two cigars on the edge of the table, which also seem to be leaning in to listen.

The fact that Münter could translate her new technical repertoire into such an accomplished language of caricature demonstrates her artistic virtuosity. It also suggests an urge to gain a certain distance from the rather earnest avant-garde discourses on aesthetic and spiritual renewal, led by Kandinsky, which surrounded her. In many ways, it is the fact of the transformation into caricature of those artistic techniques of 'synthesis', associated with Jawlensky and Kandinsky, that strikes the more profound satirical note here. Indeed, the rendering of the oil lamp, comprised of stacked abstract elements that appear ready to topple over as they pile upwards and out of the picture frame, might be read as an ironic comment on Kandinsky's drive towards visual abstraction and spiritual transcendence.

Whether *Listening (Portrait of Jawlensky)* was intended to puncture an overly inflated culture of theoretical prevarication, or was a way for Münter to exorcise her own feelings of intellectual inadequacy, expressed in her contemporary correspondence, is uncertain. However, whilst many of her portraits, especially those of women (see cat. 8, 20–21), are sober and reflective expressions of inner emotion, the fact that she returned periodically to the comic distortions of caricature suggests that such work also had an important expressive function within her artistic practice.

1 Interview with Edouard Roditi, 1958, in Edouard Roditi, Edouard Roditi, *Dialogues on Art*, Secker & Warburg, London, 1960; Horizon, New York, 1961 p. 117.

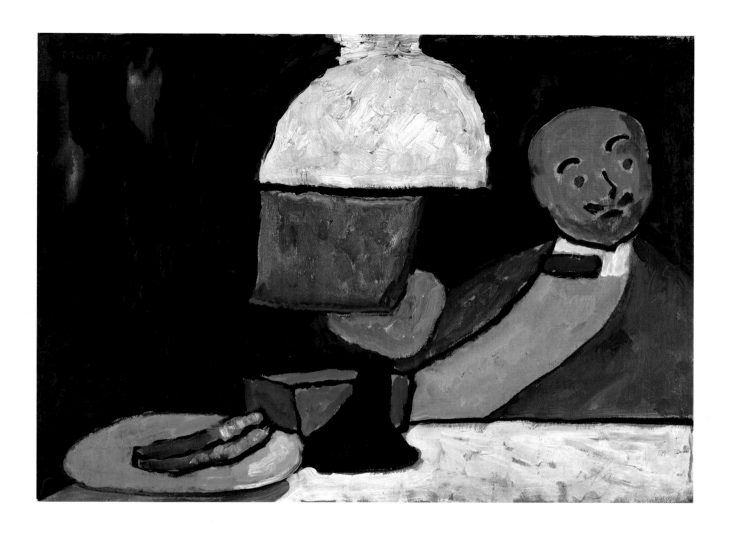

11. Still Life with Chair
Stilleben mit Sessel

1909

Oil on board
72.5 × 49 cm
Gabriele Münter- und Johannes Eichner-Stiftung, Munich

This was one of seven large paintings that Münter submitted to the second NKVM exhibition, which opened at the Thannhauser Gallery in Munich in September 1910. As well as work by her NKVM colleagues, this exhibition included a considerable number of leading artists from the French avant-garde. Although Münter had previously shown work at the large-scale group exhibitions of the Salon des Indépendants and Salon d'Automne in Paris, this was one of the first opportunities for her paintings to be displayed in a smaller, more select, exhibition, alongside artists such as Georges Braque, André Derain and Pablo Picasso. Given the significance of this exhibition, Münter must have considered *Still Life with Chair* to be a particularly important statement of her artistic practice; however, it has often been overlooked in subsequent art historical accounts of her work.

Still Life with Chair shows a peculiar arrangement of stylised vases of flowers and potted plants on a large armchair (that appears to be missing one arm), above which hangs a decorated plate, seemingly emitting a sun-like yellow glow that illuminates the left-hand side of the picture. As with Münter's other still lifes (see cat. 2), the particular significance of her choice of composed objects remains uncertain. Indeed, unlike Münter's more celebrated *Dark Still Life (Secret)*, 1911 (cat. 17), which stresses, albeit ambiguously, the symbolic value of the represented objects, *Still Life with Chair* is comprised of familiar items of purely domestic decoration. However, by bringing them together in this contrived manner, abstracting them from their normal domestic setting and function, Münter renders the familiar strange in ways that compel the viewer to comprehend the abstract formal – and perhaps spiritual – values of these objects without eroding their objective integrity. Her use of bold black outlines filled with strong blocks of colour confirms the unimpeachable solidity of the objects.

In his discussion of the second NKVM exhibition, which he sent to the gallery's owner Heinrich Thannhauser in 1910, the painter Franz Marc recognised that the desire to 'spiritualise material reality' was a unifying feature of work by Jawlensky, Kandinsky, Münter and other members of the NKVM. However, whereas this was a broadly shared ambition, their individual means of achieving it were markedly different. By exhibiting *Still Life with Chair*, Münter marked out her distance from Kandinsky's firm moves towards the spiritually transcendental values of pure abstraction and from Jawlensky's lack of concern for the material context of the objects he painted. Instead, with this painting, Münter firmly established her desire to achieve abstract and spiritual value through tangibly material objects taken from her everyday life.

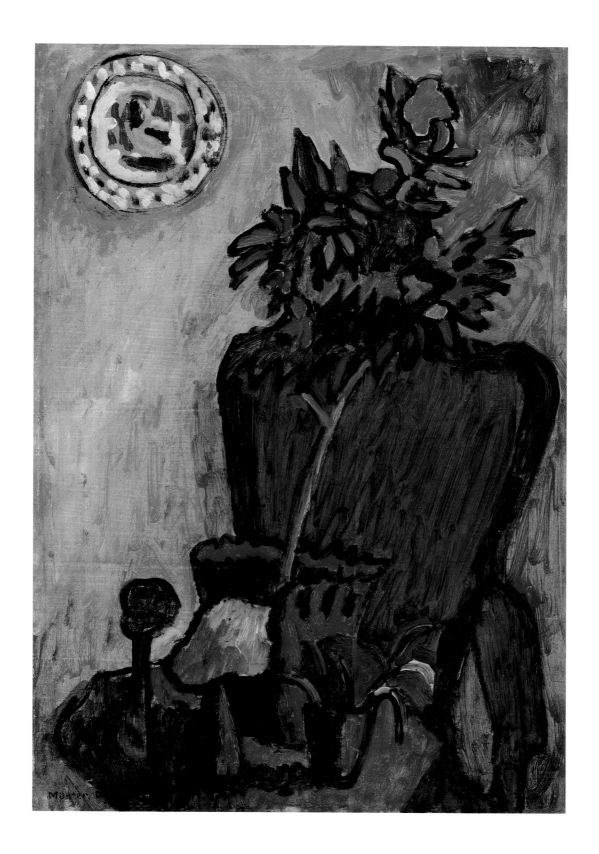

12. Three Houses in Murnau
Drei Häuser in Murnau

1909

Oil on board
33 × 41 cm
Private collection, London

Three Houses in Murnau is an image of the town very different from the one Münter presented in *Street in Murnau* of the previous year (see cat. 6). Rather than forging organic connections between architecture and nature as she had before, this painting offers a taut distinction between the rigid geometries of the white houses, painted with linear strokes, and the more unruly presence of the tree, made up of quickly applied dabs and dashes of the brush. The structuring presence of the fence, forming a grid across the bottom edge of the canvas, and the smoothly cultivated band of green grass behind, confirm a sense of order and control imposed upon the natural surroundings of these three houses. Even the tree barely broaches the roof line of the third house, such is the clarity of its role as a framing device for the scene.

It is likely that these houses, probably on the outskirts of the town, had only recently been built when Münter painted them and were part of the wider expansion and regeneration of Murnau during this period (see cat. 6). Their appearance evoked a different stylistic response from Münter – one that resisted naturalising the relationship between the town and its surroundings and instead registered a more obviously cultivated and structured side to Murnau's rural character. Münter's emphasis upon freshness and clarity in this image perhaps suggests she is extolling the sort of physically and spiritually restorative qualities of modern country living that were drawing in many visitors and settlers to Murnau from the cities at this time. As Reinhold Heller wrote recently of Murnau, 'the "unspoiled" Bavarian village . . . was a stage shaped according to a sanitizing modernist ideological celebration of rural authenticity'.[1]

1 Reinhold Heller (ed.), *Gabriele Münter: The Years of Expressionism 1903-1920*, exh. cat., Milwaukee Art Museum and elsewhere, Prestel, Munich and New York, 1997, p. 71.

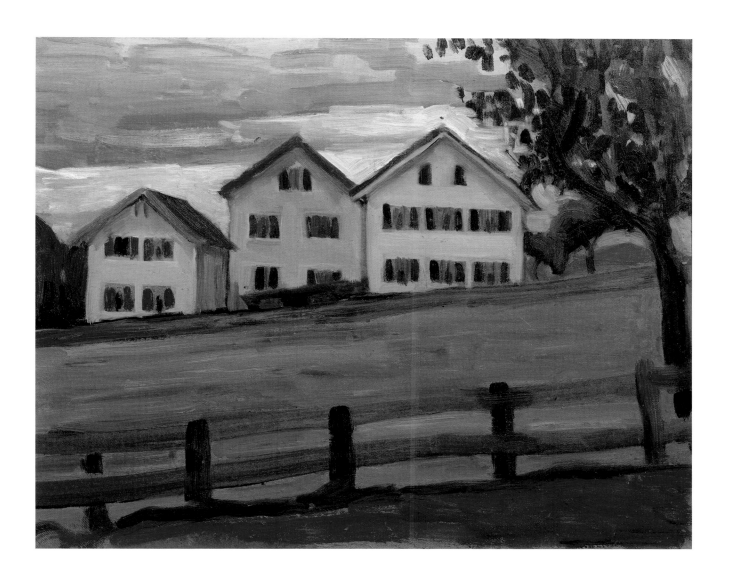

13. **Autumn Landscape**
Herbstlich

1910

Oil on board
32.8 × 40.6
Städtische Galerie im Lenbachhaus, Munich

Autumn Landscape displays an almost aggressively hard-edged approach that contrasts starkly with Münter's earlier, fluidly handled Murnau paintings such as *Street in Murnau* (cat. 6). Here, the *cloisonné* effect of black outlines is allowed to exert a more sharply defining influence over the blocks of colour, which are rebarbative shades of pink and dirty green. In the top right-hand section of the picture Münter has broken the black outline into a number of slashing strokes across the colour boundary between the pink and blue sky. If Münter's vision of nature here is a profoundly uncomfortable and desolate one, then it may be an expression of a sense of artistic uncertainty that she was experiencing during the autumn of 1910. In November she wrote to Kandinsky, 'But how am I going to find "form" – what is "form"'anyway<?> What is appropriate? What not? Should one paint, as I do, in a variety of ways?' [1]

In *Autumn Landscape* this search for 'appropriate form' is articulated through an aesthetic language that was inflected by Picasso and perhaps especially by his early Cubist landscapes of 1908–09. It was an influence she acknowledged openly in her correspondence with Kandinsky, who encouraged her to forget 'all the Picassos and Picassoists'[2] and instead to intuit and feel form as a personal vision. 'I am quite opposed to hard, overly precise form which . . . leads to a dead end,' he concluded.[3]

The assured handling of *Autumn Landscape* and the apparent ease with which Münter moved her *cloisonné* technique away from her earlier landscapes and into a starker and more confrontational aesthetic territory suggests that she was not entirely uncomfortable working in such close proximity to hard-edged abstraction. Indeed, from this point onwards she made occasional forays into such an abstract realm; however, perhaps because she heeded Kandinsky's advice, the experiments of *Autumn Landscape* did not become a central part of her future artistic practice.

1 Münter to Kandinsky,
3 November 1910, cited in
translation in Reinhold Heller (ed.),
*Gabriele Münter: The Years of Expressionism
1903–1920*,
exh. cat., Milwaukee Art Museum and
elsewhere, Prestel, Munich and New York,
1997, p. 155.
2 Kandinsky to Münter, 12 November 1910, *ibid.*
3 *Ibid.*

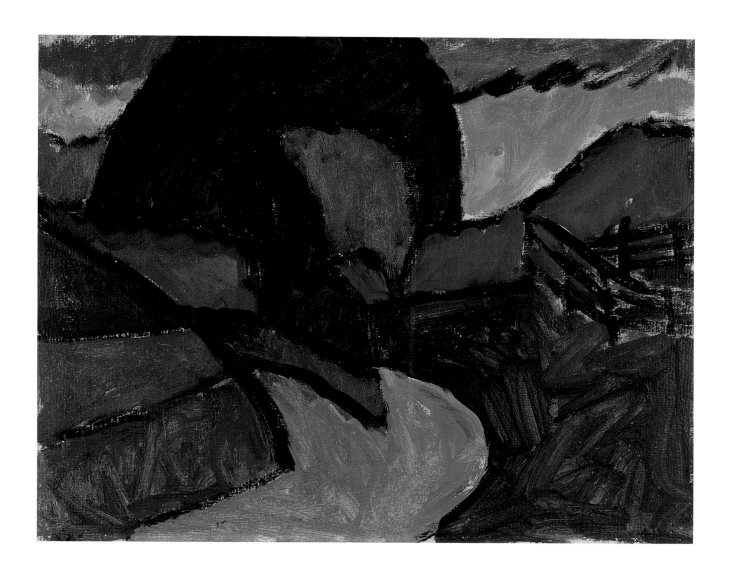

14. **Chaff Wagons**
Spreufuhren

1910–11

Oil on board
32.9 × 40.8
Städtische Galerie im Lenbachhaus, Munich

The disparity in style between this painting and *Autumn Landscape* (cat. 13) clearly demonstrates that Münter's artistic approach was not obviously programmatic, a point emphasised by her close proximity to Kandinsky, who, in conjunction with the NKVM exhibitions, was promoting his own work as being fundamentally driven by a developmental agenda. This threw into sharp relief Münter's lack of consistency, causing her a certain anxiety about her current practice. 'My works often appear to me too different,' she wrote to Kandinsky around the time of painting *Chaff Wagons*, 'but then I think that it is still one personality who makes them all different.'[1]

In Münter's landscapes the presence of a 'unifying personality' might be discerned in her steadfast commitment to expressing the changing seasonal effects of light and atmosphere upon a given scene, something that was a continuing legacy of her Phalanx school days and her earlier Impressionist-inspired *plein-air* practice (see cat. 1). *Chaff Wagons* epitomises these concerns, taking as its subject-matter an iconic rural image of the beginnings of winter, the collection of chaff for the livestock over winter.

Although the representation of agricultural activity was not usually a prominent theme of Münter's Murnau paintings, in *Chaff Wagons* her emphasis upon the agrarian character of the town carries particular significance. The inclusion of telegraph wires streaking across the top section of the painting sets up a contrast between the non-mechanised traditions of local agriculture and the modern intervention of telegraphic communications connecting the town to the rest of Germany. This was inextricably linked with the modernisation brought by the railways and the rapidly changing physical and social character of Murnau itself (see cat. 6). It is unlikely that Münter set out to make these themes of modernity the subject of *Chaff Wagons*; rather they register in the painting as part of her exploration of the seasonal effects of winter – indeed, the telegraph lines are only made manifest by the snow.

1 Letter from Münter to Kandinsky, 5 November 1910, cited in Anne Mochon (ed.), *Gabriele Münter: Between Munich and Murnau*, exh. cat., Busch-Reisinger Museum, Harvard University, 1980, p. 29.

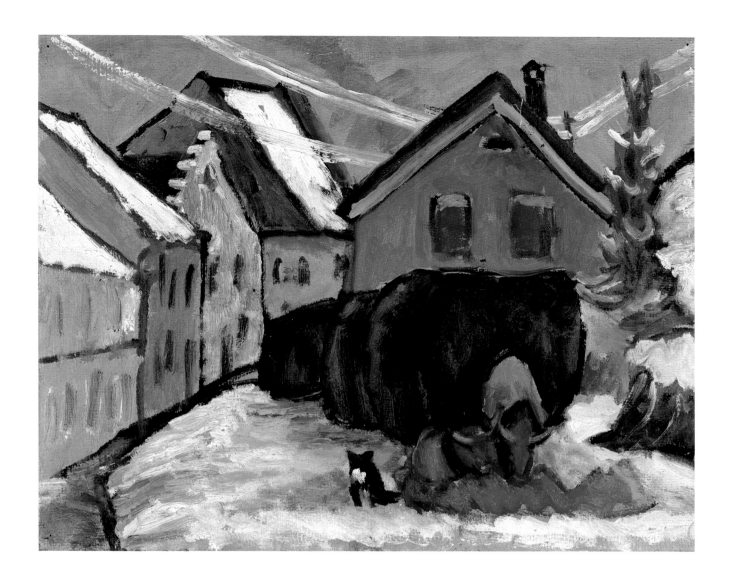

15. **Village Street in Winter**
Dorfstraße im Winter

1911

Oil on board mounted on panel
52.4 × 69 cm
Städtische Galerie im Lenbachhaus, Munich

Village Street in Winter is one of several paintings from around this time that seem to be influenced by Picasso's early Cubist landscapes, to which Münter responded in a variety of ways (see cat. 13). However, whereas Picasso's work tended to question physical integrity, Münter's piled-up cubes of gently distorted buildings establish a coherent structural presence that is given a plausible sense of perspective by the silhouetted figure and farm animal walking between the buildings on the right-hand side of the picture. The vibrant contrasts of colour between different façades of the buildings pick out a visually pleasing rhythmic pattern from this architectural jumble.

 Münter takes obvious pleasure in accentuating the ramshackle nature of the buildings and in expressing the unplanned and accidental character of their vernacular charm, such that even the line of washing strung up from a convenient fence-post contributes to the visual dynamic of the scene. It is perhaps significant that Münter figures the local inhabitants of the village as walking in the shadows of her brightly coloured vision of this rural vernacular idyll. It suggests that she found it difficult to incorporate them into her painting for a number of aesthetic reasons, not least that their more prominent presence would certainly inject a narrative aspect at odds with her primarily visual concerns, which, by extension, may have compromised her idealistic response to the rural landscape.

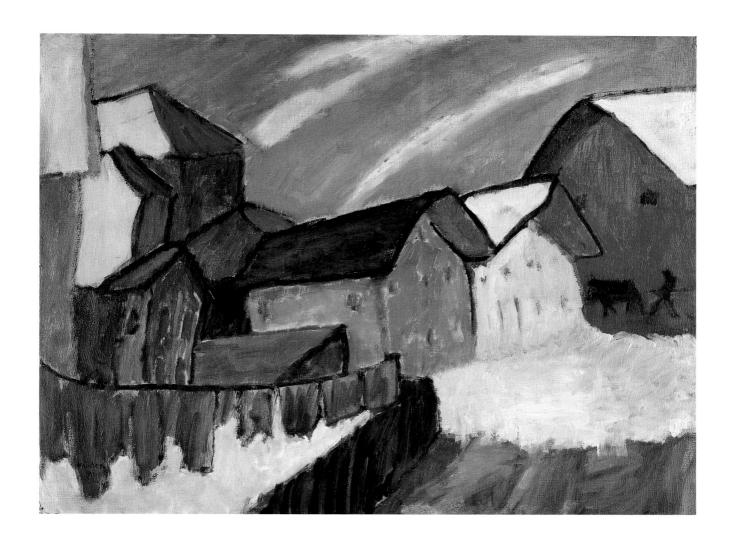

103

103

16. Man at a Table (Kandinsky)
Mann am Tisch (Kandinsky)

1911

Oil on board
51.6 × 68.5 cm
Städtische Galerie im Lenbachhaus, Munich

Münter's conjunction of the genres of still life and portraiture in *Man at a Table (Kandinsky)* was a characteristic feature of many of her paintings (see cat. 10, 21). Her technique of reducing form and colour to an essential level, which had become a cornerstone of Münter's modernist aesthetic, presented considerable challenges for portraiture where some degree of likeness remained important to her. As she wrote in 1952: 'I have often attempted to do portraits, but I must confess that not many likenesses have been really successful. Sometimes a good picture results, but not an accurate portrait; sometimes a genuine portrait but not a suitable picture.'[1]

Bringing still-life elements into her portraiture was one of the ways in which Münter dealt with this problem, allowing her to render the minimum amount of external facial details needed for recognition whilst expressing inner aspects of her subject's identity, such as psychological and emotional characteristics, through their surroundings. In this painting, the huddled figure of Kandinsky recedes into the background, while by contrast the abstractly described still-life objects are accorded a more prominent position, attention being drawn primarily to the large pot-plant branching out up and across the canvas.

Man at a Table (Kandinsky) was reproduced in the *Blaue Reiter* almanac as part of Kandinsky's essay, 'On Stage Composition'. The essay offered a critique of the conventions of various stage arts as a preface to his own stage composition, *The Yellow Sound*, which sought to arrange the vital elements of sound, movement, colour and form in order to achieve outward expression for what he described as the inner 'vibrations' of the artist's soul. In this context the rhythmic shapes of the composed still-life objects and the stave-like form of the pot plant in Münter's painting offer a visual analogue for these ideas. In this sense *Man at a Table (Kandinsky)* is a portrait of Kandinsky's intellectual and artistic preoccupations and the fact the these cerebral aspects are given such prominence in the painting, whilst his physical appearance recedes in shadow, suggests that the emanations of his mind were Kandinsky's defining characteristics.

1 Gabriele Münter, 'Bekenntnisse und Erinnerungen', in G.F. Hartlaub, *Gabriele Münter: Menschenbilder in Zeichnungen*, Berlin, 1952, cited and translated in Anne Mochon (ed.), *Gabriele Münter: Between Munich and Murnau*, exh. cat., Busch-Reisinger Museum, Harvard University, 1980, p. 31.

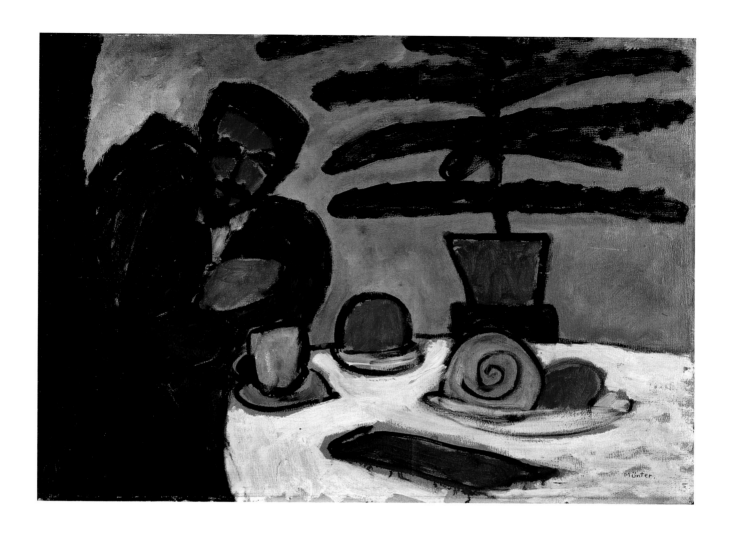

17. Dark Still Life (Secret)
Dunkles Stilleben (Geheimnis)

1911

Oil on canvas
78.5 × 100.5 cm
Städtische Galerie im Lenbachhaus, Munich, Dauerleihgabe der
Gabriele Münter- und Johannes Eichner- Stiftung

This major painting was one of the works Münter exhibited at the first *Blaue Reiter* exhibition, which opened at the Thannhauser Gallery in December 1911. A closely related painting, *Still Life with St George* (fig. 13, p. 32), was reproduced in the *Blaue Reiter* almanac and discussed by Kandinsky in his essay 'On the Question of Form', confirming the importance of this style of still-life painting for Münter's artistic identity within the newly established *Blaue Reiter* group.

Identifying the subject-matter of *Dark Still Life (Secret)* is not straightforward, as Münter's use of inconsistent lighting effects makes the arranged objects shade into darkness, whilst apparently significant parts are dramatically illuminated by some undisclosed light source. This creates spatial ambiguities that intensify and displace the suggestion of a narrative content and, although the mysterious lighting seems to stress the objects' symbolic significance, this is compromised by the 'secret' relationships existing between them. It is clear from contemporary photographs of Münter and Kandinsky's Munich apartment (fig. 36, p. 67) that the objects of *Dark Still Life (Secret)* come from their collection of Catholic folk-art (see cat. 7). The pair of figures on the left-hand side of the picture has been identified as a Bavarian glass-painting depicting the King of Bohemia and St Nepomuk; other objects include an earthenware hen, a red Easter egg and a handpainted goblet. However, knowing the identity of these objects complicates rather than clarifies the meanings generated by their representation in *Dark Still Life (Secret)*. Divorcing them from their original context, Münter entangles their traditional symbolic meanings in the mythic phantasmagoria of her personal vision in ways that emphasise the *process* of spiritual contemplation as the viewer attempts to make sense of the picture. The fact that as a Protestant Münter was an outsider to these objects of Catholic devotion may have deepened the intensely mysterious nature of the vision she expresses here.

Although Münter's presence within the *Blaue Reiter* exhibition and the almanac was eclipsed by the likes of Kandinsky and Franz Marc at the head of the group, *Dark Still Life (Secret)* was a profound and distinct engagement with the group's ideology of individualistic spiritual and artistic renewal based upon the 'primitivism' of folk art and the selective reprise of mythological and religious cultural traditions. However, in contrast to Marc and Kandinsky's desire to produce paintings that could connect directly with a spiritual realm, Münter's concern in *Dark Still Life (Secret)* to emphasise the process of contemplation itself through the representation of actual devotional objects places a certain evaluative distance between the material and spiritual realms.

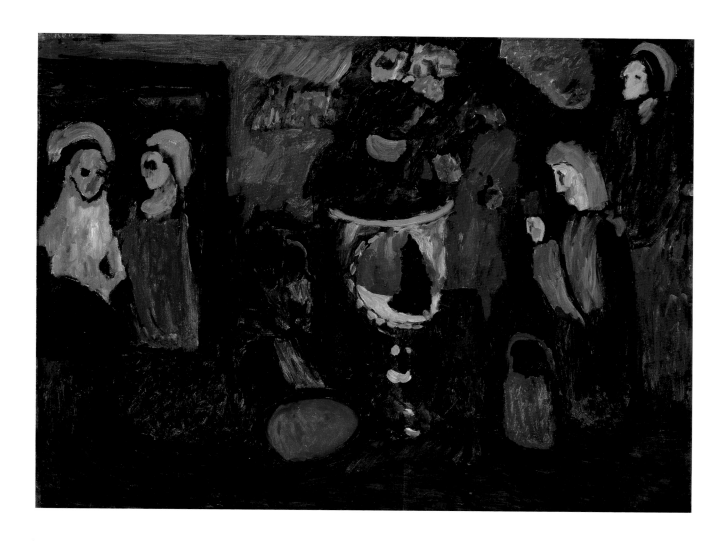

18. Black Mask with Pink
Schwarze Maske in Rosa

1912

Oil on canvas
60.4 × 49 cm
Gabriele Münter- und Johannes Eichner- Stiftung, Munich

This still-life arrangement is unusual in Münter's oeuvre at this time because its subject-matter and handling seem unconnected with the religious folk art objects and aesthetics of her other still lifes (see cat. 17). Whereas these works emphasise themes of devotion and spirituality, *Black Mask with Pink* seems to concentrate on purely formal and decorative relationships between the sweet coloration and exuberance of the pink costume-like motifs and the fixed expression of the life-like black mask that nestles within them.

However, if this painting seems distant from the devotional rituals of her other still lifes, its black mask and pink costume-like elements engage with another form of ritual – the carnival and perhaps specifically the Bavarian Fasching festival that takes place before Lent.[1] Like other manifestations of the carnivalesque, the Fasching has its most direct origins in the festivals of the Middle Ages during which the lower orders of society were licensed to subvert rank and indulge in celebrations of excess and ribaldry. In the case of the Fasching, the excess of revelry precedes the rigours and control required for the fast over Lent. In this context, *Black Mask with Pink* is profoundly connected with works such as *Dark Still Life (Secret)* (cat. 17), as a profane counterpart to the sacred religious traditions of devotional folk-art.

It is perhaps significant that the negative critical reception of both the NKVM and *Blaue Reiter* exhibitions was imbued with accusations of subversion, grotesquery and charlatanism. In his review of the NKVM's first exhibition, Hermann Eßwein linked the event to carnivals directly, describing the show as 'an early Fasching diversion, an artist's trick'.[2] With *Black Mask with Pink* Münter may have been toying with these critical themes of masquerade while at the same time engaging with the European avant-gardes' wider fascination with masks and their associations with ritual and identity.

1 I am indebted to Shulamith Behr for drawing my attention to the connections between this painting and the Fasching and for the further connection with Hermann Eßwein's review in the *Münchner Post*, 10 December 1909.
2 Hermann Eßwein, Münchner Post, 10 December 1909: '...ein verfrühtes Faschingsvergnügen, einen Künstlerulk'.

19. **Dragon Flight**
Drachenkampf

1913

Oil on board
36 × 43.2 cm
Gabriele Münter- und Johannes Eichner-Stiftung, Munich

The subject-matter of this painting is a Russian folk-art wooden carving of *St George and the Dragon* that was in Kandinsky and Münter's collection. A photograph of the sculpture (fig. 41) appeared in the *Blaue Reiter* almanac in 1912, the year before Münter painted this work. St George was an important symbolic figure for the *Blaue Reiter* group, his slaying of the dragon and rescue of the princess seen as emblematic of the artist's spiritual mission to overthrow the evils of corrupt materialist culture and recover the innocence of aesthetic purity.

The blue coloration and amorphous background shapes of Münter's *Dragon Fight* recall Kandinsky's *Blaue Reiter* almanac cover-illustration of St George (fig. 14, p. 33). However, the diminutive, toy-like appearance of Münter's St George and the child-like manner of the painting's execution lack the intensity and vigour of Kandinsky's woodcut, undermining some of the rhetoric of heroism and salvation associated with the 'horseman' of the *Blaue Reiter*.

Whether Münter intended *Dragon Fight* to be a confrontational riposte to Kandinsky's images of St George is uncertain. However, as patron saint of both Murnau and Moscow, St George was invested with a complex array of personal meanings and autobiographical significances for the couple. It is possible that this painting was a way for Münter to meditate upon their relationship, perhaps during the several months Kandinsky was away in Moscow during the second half of 1913; indeed, she produced at least one other version of the painting at this time.

In retrospect, *Dragon Fight* embodies a number of cruel ironies for the couple, not least the crumbling of its symbolism of personal and national unity upon the outbreak of the First World War, when Münter and Kandinsky found themselves cast as 'enemies' on separate sides of the conflict; Kandinsky returned to Russia in 1914, returning briefly to Stockholm in 1916, after which they were never to see each other again.

Fig. 41 Russian folk-art sculpture, *St George and the Dragon*, 19th century
Wood
Gabriele Münter- und Johannes Eichner-Stiftung, Munich

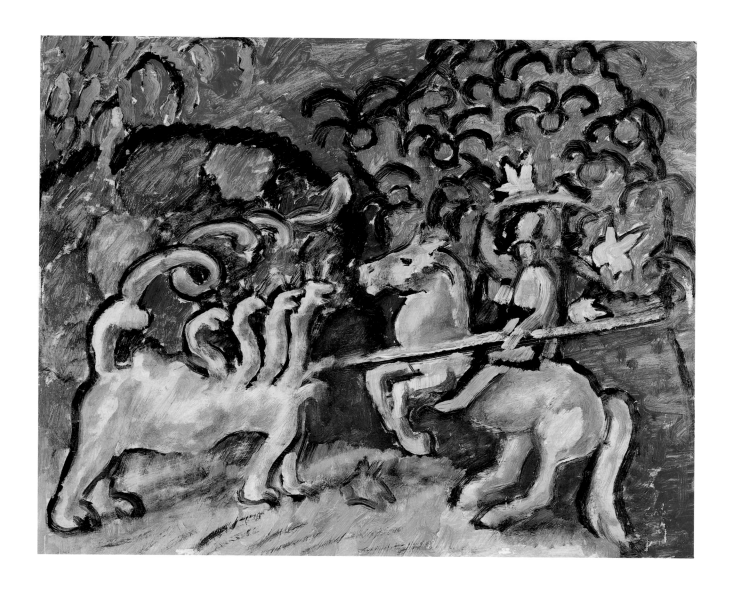

20. Portrait of Gertrude Holz
Bildnis Gertrude Holz

1917

Oil on canvas
75 × 58.3 cm
Gabriele Münter- und Johannes Eichner- Stiftung, Munich

Portrait of Gertrude Holz belongs to a series of paintings of women in interiors that Münter produced towards the end of her stay in Stockholm, where she lived for over two years following her separation from Kandinsky. The sitter for many of these paintings was her friend Gertrude Holz, with whom she had spent time travelling to Lapland and along the west coast of Norway the previous year.

Rather than concentrating upon specific aspects of Holz's character, Münter expresses abstracted themes of isolation, melancholy and reverie through this and other portraits (see cat. 21). Holz gazes out of the picture in wistful contemplation, her face and neck tinged with soft blue tones that continue into the space surrounding her head as if extending her thoughts into a meditative aura. The framed picture behind could be the subject of her thoughts, although its indistinct image adds an enigmatic note to her contemplation. This picture within the picture also emphasises the theme of introspection that pervades the general mood of the painting.

Portrait of Gertrude Holz demonstrates a marked change in Münter's approach to the representation of women from her earlier portraits such as *Portrait of a Young Woman in a Large Hat (Polish Woman)* (cat. 8). Whereas the 'Polish Woman' engenders determined optimism, Holz seems to embody a sense of reflective detachment. Although such a dramatic change in emphasis might be related to Münter's own feelings of isolation following her break-up with Kandinsky and divorce from the rest of the *Blaue Reiter* circle, *Portrait of Gertrude Holz* is far from being maudlin. As Shulamith Behr has noted of these portraits, they 'focus attention on the contemplative mood, short hair-styles and reform dress of early twentieth-century womanhood'.[1]

1 See Shulamith Behr's entry, 'Gabriele Münter' in D. Gaze (ed.), *Dictionary of Women Artists*, London, 1997, p. 999.

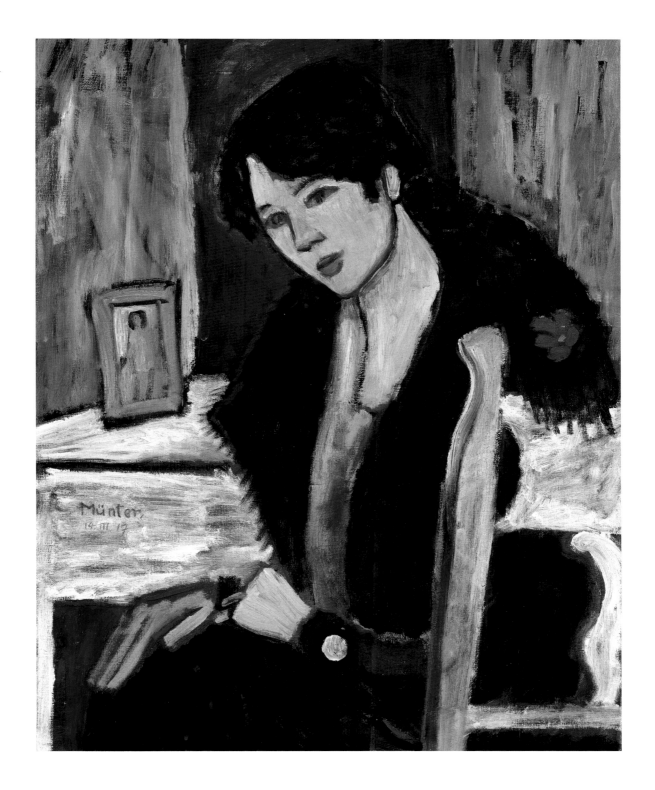

21. Reflection
Sinnende

1917

Oil on canvas
66 × 99.5 cm
Städtische Galerie im Lenbachhaus, Munich

Reflection is one of Münter's most important Swedish portraits of women in interiors. As with many in the series, the sitter in this painting is Gertrude Holz, although the title refers only to the emotional state represented (see cat. 20). *Reflection* is a confident summation of Münter's new style and technique that she had developed whilst working in Stockholm in contact with Swedish avant-garde artists such as Isaac Grünewald and Sigrid Hjertén, who had trained with Matisse in Paris.

During this period Münter modified her earlier *cloisonné* technique, which had previously functioned to reduce and simplify form, to place new emphasis upon the use of line to express rhythmic complexities. Her approach to colour underwent a parallel transformation as she began to favour a subtle palette and softer gradations of tonal contrast. Her new concern for decorative design in *Reflection*, with its extraordinary swathe of complex patterning, shows the influence of Grünewald and Hjertén and their interpretation of Matisse's principles of decorative expression. However, Münter's subordination of these techniques to her central theme, in this case thoughtful reflection, is distinct.

Here, Münter sets up a distinction between the marbling effect of flowing line and colour in the background and the sculptural treatment of the figure of Holz, her nose and eyebrow seemingly carved in relief. This establishes a hierarchy between the 'objective' integrity of the face and figure and the sense of 'subjective' emotion and thought evoked by the band of swirling decoration entangled with the structured grid of the window. Holz's 'crown' of blue tulips links the physical with the emotional and cerebral realms, creating a dualism that is comparable to Münter's earlier *Man at a Table (Kandinsky)* (cat. 16).

Reflection is a crystallisation of Münter's belief in the importance of maintaining the dualist character of the physical and spiritual realms. These ideas had been shaped by many discussions with Kandinsky and register in various ways in all of her works from the previous decade. However, Kandinsky's adherence to pure abstraction from the time of their separation onwards contrasts strongly with the representational commitments of *Reflection* and in this sense the painting can be seen as a valediction to Kandinsky. Writing in 1952, Münter articulated those ideas central to *Reflection*, providing a retrospective summation of her approach to portraiture specifically and her artistic beliefs more generally:

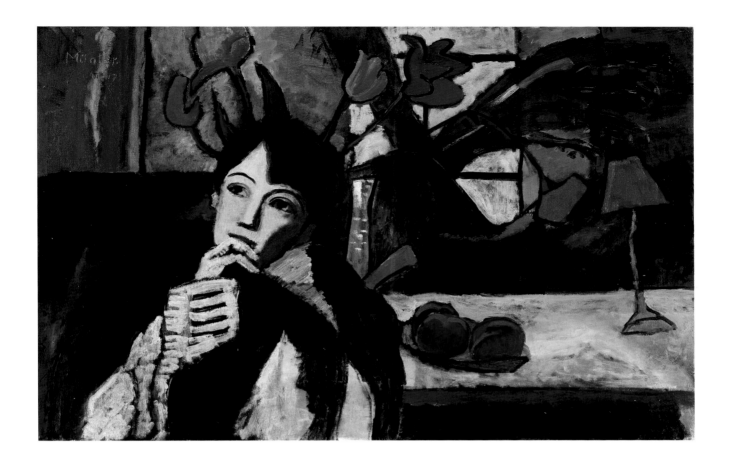

'The task of representing the human being is so great that I never felt myself tempted to go beyond it, for example to dissolve the human appearance, to submit it to wilful reconstructions and to replace it with non-objective imagery. One may believe that in this manner the spiritual in itself is grasped, that in a certain sense the aura of the human is depicted [or that] an analogue, a symbol is created. But the bodily appearance of the human being, specifically the face, is already a symbol. Because personality is rooted in the spiritual and is active from within the non-visible. For this non-visible, which is what matters, the visible body is the natural symbol.'[1]

1 Gabriele Münter, 'Bekenntnisse und Erinnerungen', in G.F. Hartlaub, *Gabriele Münter: Menschenbilder in Zeichnungen*, Berlin, 1952, cited and translated in Reinhold Heller (ed.), *Gabriele Münter: The Years of Expressionism 1903–1920*, exh. cat., Milwaukee Art Museum and elsewhere, Prestel, Munich and New York, 1997, p. 111.